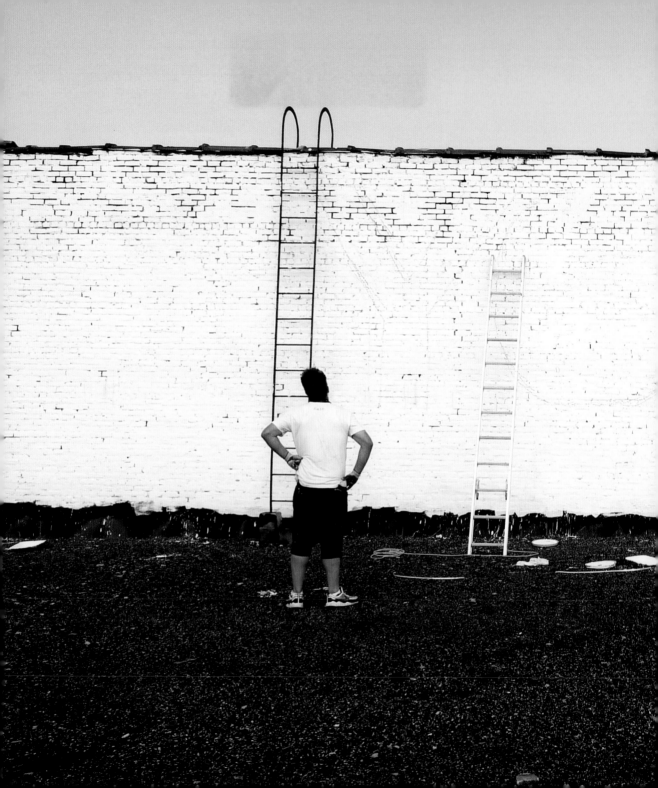

# A LOVE LETTER TO THE CITY

## Stephen Powers

**Foreword by Peter Eleey**

Princeton Architectural Press · New York

Published by
Princeton Architectural Press
37 East Seventh Street
New York, New York 10003

Visit our website at www.papress.com

Editor: Sara Stemen
Editorial assistant: Merrell Hambleton
Designer: Anthony Smyrski
Chapter titles: Matt Wright for Long Shot Signs
Photo assistant: Matthew Kuborn

Special thanks to:
Meredith Baber, Sara Bader, Nicola Bednarek Brower,
Janet Behning, Megan Carey, Carina Cha, Andrea Chlad,
Barbara Darko, Benjamin English, Russell Fernandez,
Will Foster, Jan Hartman, Jan Haux, Diane Levinson,
Jennifer Lippert, Katharine Myers, Lauren Palmer,
Margaret Rogalski, Jay Sacher, Elana Schlenker,
Rob Shaeffer, Andrew Stepanian, Paul Wagner,
and Joseph Weston of Princeton Architectural Press
—Kevin C. Lippert, publisher

Library of Congress Cataloging-in-Publication Data (for
 paperback edition):
Powers, Stephen, 1968–
  A love letter to the city / Stephen Powers ; foreword by Peter Eleey.
 — First edition.
     pages cm
  ISBN 978-1-61689-208-1 (alk. paper)
  1. Powers, Stephen, 1968—Themes, motives. 2. Street art. 3. Graffiti.
4. Artists and community.  I. Eleey, Peter, writer of supplementary
textual content. II. Stephen, 1968- Works. Selections. III. Title.
  N6537.P665 2014
  751.7'3—dc23
                    2013025686

Image credits: Adam Wallacavage: frontispiece, 52–69, 73 bottom,
76–83, 86–87, 89–93, 163 bottom right. Alain Levitt: 22–23, 29. Dan
Murphy: 75, 94–95, 108–109, 111–13, 166–67. Dave Villorente: 118–21,
128, 134–35. Flavio Samelo: 97, 98–99 top, 100–107. Lew Blum: 171.
Lila M.: 43 left. Joey Garfield: 10–11, 163 top left. Martha Cooper:
140–47, 150–53. Matthew Kuborn: 114–17, 122–23, 126–27, 136–37,
162, 163 top right, 164–65, 168–69. Mike Langley: endsheet artwork.
Molly Woodward: 124, 130–31, 138–39. Patrick Griffin: dedication
page. Sean Barton: 156 artwork. Sean Schwab: 9. Sam Meyerson: 133.
Steve Powers: 13–15, 17–21, 25–26, 30–37, 39–42, 43 right, 44–51, 73 top,
154–55, 158–61, 163 middle right, bottom left. Timothy Greenfield-
Sanders: 16. Will Robson-Scott: endsheets, 2.

This book is dedicated to the vivid memory of NEKST MSK.

# CONTENTS

 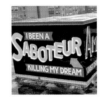
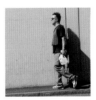 

# FOREWARD

"Foreword" was misspelled when hand painted. We kept it because sign painters are always misspelling signs. The more you concentrate on letters, the less you concentrate on words.

## PETER ELEEY

The history of public art is denominated by ownership, authorship, location, and duration. For whom is it made, by whom, for where, and for how long? Combining property deface-ment with an insistently self-serving voice and materials selected for their relative perma-nence, graffiti is rarely welcomed as public art. We consider it something else: public expres-sion, yes, but a declaration of presence and unearned ownership from the undeserving and unwelcome to the community of law and order. "Graffiti is a signal broadcast from the periph-ery of the community to the center," Steve Powers explains, and he knows.

At some point in the late 1990s, exterior sur-faces around New York began to be painted in a particular kind of community outreach. Tags were obscured under "buffs" of paint rolled onto defaced storefront grates; careful view-ers could spot a new writer emerging over-top, his name defined by the negative spaces left unpainted. But it was an old name, writ differently. Détourning the restorative buff to authorial ends, Powers pioneered a new form of graffiti and public art, dressing itself (and

himself) up in the benevolence of community service. Employing a base hieroglyph for the new century borrowed from the suburbs of the last, he laid out minimalist blocks of paint over the wobbly expressionist line of writers known and unknown, setting the opaque *colore* of the Home Depot roller over the airy *disegno* of the Montana can and the Krink marker.

Moving on to Los Angeles, Powers developed an updated, in situ turn on New Topographics style, making his buffed beige signatures in and over the banalities of the (vandalized) industrial landscape. Recalling the cool but lov-ing eye with which Lewis Baltz glimpsed the surfaces that feature in his Prototype photo-graphs of the late 1960s, Powers found expres-sive potential in the hard geometries of the postwar urban wall. "I'm interested in stripping out the commercial [and] stripping in the emo-tional," Powers notes.

But salvation would come first in the form of commerce. Wandering down to Coney Island shortly after he put down his buff roller, Powers saw the weathered hand-lettered signs for amusements being replaced with computer-cut

vinyl. In short order, he painted a new sign for the Eldorado Arcade on the Bowery for free; by the time the cars of the Cyclone roller coaster started rattling along their tracks that May, he had repainted them, too. Along the way, in the name of public art and in the spirit of community service, I helped Powers organize an ad-hoc "club" of artists working under his example to redecorate a place once called Dreamland. With the assistance of "Mayor" Dick Zigun, we knocked on the fogged windows of sedans that were the off-season social clubs of Jones Walk and then tried to get our pitch out to shop owners in the few seconds before they rolled their windows back up. In the end, almost no one refused our services.

The next year, more signed on, and Powers opened a lettering shop on Surf Avenue, offering handwritten and painted signs for the asking, alongside his own work. And with that, like the kids at the track derby around the corner, he was off to the races. Though he still letters for hire (and sometimes simply for thanks), Powers discovered in Coney a way to serve the community and still retain his voice. He refined what he surely had suspected as he buffed on both coasts: that his voice was more than just his name. And that he could magnify it by working with, and through, others.

Getting up but fixing up, he now provides text messages that aren't instant, but which last only as long as the 1 Shot with which they are painted. He offers self-help slogans turned outward to the neighborhood, with a punning visual style that mines the tricks of street trade as easily as his phrasing mimics the motivational calendar and the condolence card. Speaking in the solicitous tones of bathroom scrawl and personal ad, he evokes both the romance of missed connections and the exhortations of political slogans. His murals humanize the anonymity of the urban landscape, not least because he works closely with the communities who see them. But importantly, they remain anonymous, which allows them to do their work. They are love letters that convey the feelings of a city back to itself, while advertising nothing more than the business of life.

"Service is our only product," exclaims the slogan of Powers's itinerant sign-painting business, deftly disguising its less charitable origins in the West Philadelphia of the 1980s. This book tells the history of that personal product and its public offering, which was eventually issued amid the fried clams, sand, and barks of a fading Coney Island, and which franchised its service line to the masonry, train bridges, and underpasses of Ireland, Syracuse, Brooklyn, Brazil, South Africa, and beyond. Getting over and staying up, it nevertheless preserves the lettered ghosts of old economies and the communities who sustained them, these valentines from painters of yore, scrawled to the future on the bricks of the past.

Powers is a traveling salesman for the social media age, in which the things we can't find, say, or share online often turn out to be the very goods we need. And so he heads out on foot, knocking on doors, putting up ladders, and rolling out paint. The world's a big place, but as he would point out, on the road most traveled, there is no reason to ever leave home unless you are making the road better. Look for the man in the yellow raincoat hawking something at the corner of "Above" and "Beyond."

# *INTRODUCTION*

## STEPHEN POWERS

I was born in Lankenau Hospital, but, curiously enough, on my birth certificate they make a point of listing my birthplace as Overbrook, Pennsylvania, although I'm 100 percent certain that Lankenau is in Lower Merion. Lower Merion's price for rejecting me? Stolen Polo garments off the township's clotheslines and stolen paint and bikes out of its garages. We're even now, thanks.

My mother grew up nearby, in a rented apartment in a good-looking building at Lancaster and Drexel. By the time I hit the scene, she had moved a block and a half away to a run-down slum house with twenty-four (yeah) cats and five humans who were doing their best not to interact with each other. We were joined by my little sister a little more than a year later, and our bizarro-world Brady Bunch was complete. Dad we called Fad, after my oldest brother's mispronunciation of "dad." The name fit because he wasn't much of a father, and he passed through my life like a fad. Haven't seen that fool in twenty-five years. He split when I was fifteen, when my latest and greatest interest was an activity that demanded that I have

a distracted single parent unable to grasp that I was running wild (well, mild) at all hours. So, Earl, thanks for leaving—really, no hard feelings. And Mary Jane, thanks for staying and keeping the lights on for when I (eventually) got home.

So once my dad kicked the bricks, I went out and found me a real role model—a stand-up guy who had his head screwed on tight and good data to unselfishly share with me, for nothing more than the paint I would supply for the lesson. Suroc, aka Nick-E-Dee, aka Falcon, aka Buford Youthword from Avondale Street, showed me the ways and means of making a name for myself. He took me to paint my first few rooftops on Market Street in Philadelphia. The rooftops were the perfect location for work—largely forgotten spaces on the tops of buildings. Youth would climb up to display for the passing trains and their passengers the names that encapsulated their personalities: Razz, Estro, Mr Blint, Credit, Clyde, Ran, and Maniac, to mention a few. Suroc and I spoke our piece alongside those guys and added to the visual cacophony that was Market Street in the 1980s.

One day in the early 2000s it all got buffed brown. Nobody remembers when exactly, but it happened: efficiently, completely, permanently. I find it interesting that no one noticed that a hundred full-color walls suddenly went brown. That was always the problem with graffiti. For all its efforts to communicate, most people don't understand it, and if people don't understand, they don't take ownership, and your name gets taken down like a campaign poster in December. In our fame-addled America it's easy to understand the motivation to write your name, a lot harder to appreciate the unreadable result. If you do make your name easy to process, you leave your audience cold after the tenth time they've seen it—never mind the hundredth or the thousandth.

But that was all future history on a distant horizon. In the 1980s graffiti looked permanent. In the summer of 1987 I was nineteen years old—too old for writing graffiti, but I had just graduated from high school, barely, and was extending my vacation before embarking on a vocation. I knew that vocation was to be an artist. How and when were questions my head was asking and my heart was ignoring. My heart was busy with graffiti, and I told myself that the design, color, and adventure that graffiti-writing offered would serve me well when I was ready to grow up. The city of Philadelphia was covered in writing; I was out there every day, up and down streets looking for it, and every night I climbed up and down buildings, writing.

The graffiti in Philadelphia was so prevalent that you had a right to be skeptical that there was a government agency called the Philadelphia Anti-Graffiti Network. But PAGN, in spite of its clumsy acronym, was starting to turn the tide against what initially had been considered a positive, if unsightly, alternative to the youth-gang slaughter that had defined and defiled the inner-city youth experience of the late 1960s and early '70s. PAGN had a two-pronged strategy for combating graffiti: (1) Paint over it with red paint and (2) draft writers into its own mural program, offering jobs if they put down the spray can and picked up a brush. I understood number one, but number two was a real sore point with me. Why did I have to give up spray paint? Why did I have to use a brush? And, most grating, why did I have to have my sketches approved by a committee before I could paint? Joining up with PAGN was never a real option for me, so I stayed in the street.

On my route one day, I saw Jane Golden. She had recently moved to Philadelphia from California and had immediately attracted press for the murals she was painting for PAGN. She was a good painter and had an open-minded attitude about graffiti. She was painting a wall under a bridge that carried commuter trains through center-city Philadelphia. The wall along the tracks was covered with nicely painted names: some of them were more than twenty years old; others were twenty minutes old. It was a regular stop for me. Jane invited me up on the scaffolding and offered me a job assisting her. I asked about the process of getting her sketches approved, and she admitted it was a lengthy one. I laughed and told her I was going to show her something the next time I saw her. I said goodbye and climbed off the scaffolding.

That night I painted the wall next to the train tracks above Jane's mural. I painted a red square, and in the center of that square I painted the *Mona Lisa*, her face partially covered by the red paint, disappearing under

the same red that PAGN used to paint over graffiti. In case the message was too subtle, above her face I wrote, "This Is the Network," and next to her face I wrote, "Art is long, life is short, and I don't consider the network to be a worthy judge."

The next day, after waiting at the one-hour film developer, I delivered a picture of the freshly painted wall to Jane on the scaffolding. Jane smiled and cringed at the same time. She handed the photo back to me and said, "I understand—I'm glad you're out there." Out there I stayed.

During the next twenty years Jane moved up in the ranks at PAGN, took it over, and then spun off the anti-graffiti network as the underperforming division it was. She transformed the mural program—what was once window dressing for PAGN—into the Philadelphia Mural Arts Program, a model for community building through public art that is admired and emulated throughout the world.

During the same time I moved on from graffiti and made a seamless transition into the art world, collaborating with Todd James and Barry McGee on a show we called *Indelible Market* when it was curated by Alex Baker at the Institute of Contemporary Art at the University of Pennsylvania, then *Street Market* when it was curated by Jeffrey Deitch at his gallery, Deitch Projects, in New York City. The *Street Market* show eventually went to the Forty-Ninth Venice Biennale, and while it was an amazing level to attain, I had been making paintings for only two years, and I had a lot to learn about art.

So I went back down to the street—one in particular, called Surf Avenue, in Coney Island. There I found a middle ground between the graffiti I spoke fluently and the painting language I could speak only well enough to order a beer. So I ordered a beer and made paintings that looked like Coney Island signage, except I stripped out the commercial and inlaid emotional content. The resulting art was visually clear and direct, unflinchingly confronting the complexities of love and life in a way I avoided in my everyday living. Coney Island was both sandbox and toolbox, a place where I learned to make effective paintings, perform effective community service, and be an effective carny making cash in the summer sun—all useful skills when it was time to make sign painting the voice of the community, the way Stay High had once made graffiti "The Voice Of The Ghetto."

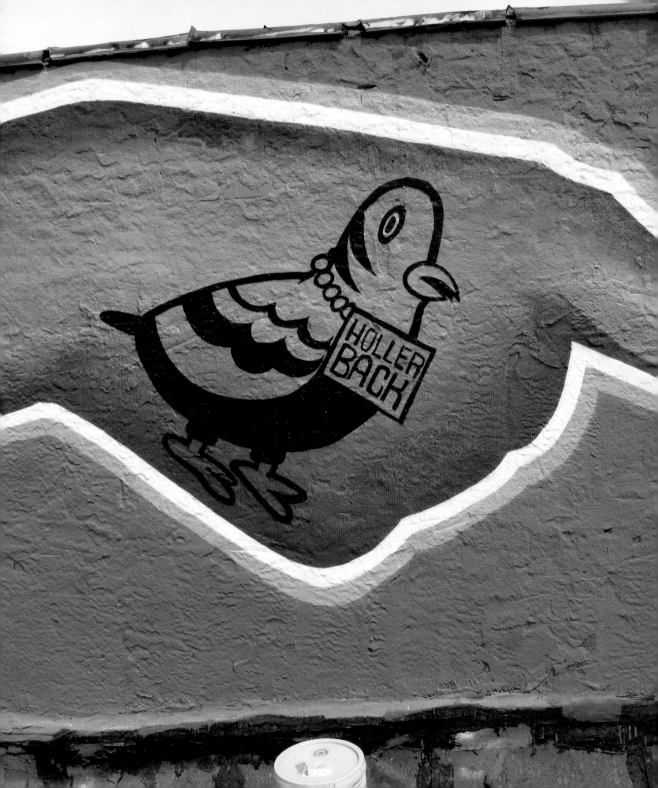

# CONEY ISLAND

On the day I moved to New York—August 1, 1994—
after the last duffel bag of clothes was dropped on the
floor, I took the F train to Coney Island and rode the
Cyclone. I got the sand in my shoes, and I returned to
Coney again and again, and every time I was inspired
and influenced by what I saw out there.

**left**: Esposer on the front car of the Cyclone.
The Cyclone is eighty-six years old and virtually
unchanged since day one. Well, in the beginning,
the ride had no cushioning and no restraints.
No wonder Charles Lindbergh said it was more
thrilling than flying across the Atlantic.

**p. 13**: Hours devoured, days slayed, months dumped,
years disappeared. As Mark Dancey told me, "Kill time
before it kills you." Oh, and "slayed" isn't a typo. No
typos in art.

In 2003 I saw that some of the best hand-painted signs were being replaced with cheap vinyl lettering. I immediately started to offer my services as a sign painter. I wasn't that good, but I wasn't charging money, so I thought I would be up to my neck in work. But in Coney Island, "FREE" means a scam, so I had no takers until Dick Zigun, a mayoral presence in the neighborhood, vouched for me, and I got my first job painting letters on the back of the Eldorado Arcade. With the help of Nate Smith, another guy who was over graffiti and looking for something else, I painted the letters across the back of the building, first in vermillion and, after complaints that it wasn't red enough, then in fire red. When we finished, nobody said "thanks." Saying "thanks" implies a debt, and no one is in debt in Coney Island. We didn't get gratitude, but we got a lot more work, and that was enough.

One day I went back to Manhattan to take a meeting at the venerable public art organization Creative Time. I was covered in paint, and I explained what I had been up to in Coney, and I saw Creative Time boss Anne Pasternak's eyebrows arch up. By the time I made it back to my apartment, it had been decided to make this a full-scale art project, which we titled the Dreamland Artist Club. Creative Time brought in forty more artists, and we painted around sixty signs. Central to the success of the project was not that famous artists were putting art in Coney Island, but that they were making useful signs for the businesses there.

Well, mostly. We set Rita Ackerman up with the best spot on the Island, underneath a large neon sign advertising the Wonder Wheel on Jones Walk and Bowery. It was a fifteen-by-thirty-foot smooth, stucco wall that sat atop a small, easily accessible rooftop. It was a wall that kids had climbed and painted for decades, and when Rita got her chance, she painted it with the same brio as a kid painting illegally: "I wanted it to look like graffiti." She painted really fast, using black paint on the white wall, and she rendered her trademark nymphs in a variety of painful carnival situations, including one who was blindfolded with a magician's knife stuck in her arm.

The neighbors were furious. Rita had successfully made graffiti that the entire block wanted painted over. We heard the complaints and thought maybe if Rita added a little color the neighbors would be mollified. Rita sprayed a can of gold paint around the figures, which, of course, made it look more graff than ever. Anne Pasternak called me, and I went down to try to cool off the situation. I started to talk to a woman who was turning sausages on a grill that faced the mural, and she wasn't hearing it, yelling at me, "I know what it's about—it's about the subjugation of women in carnival history. I get it, but it's scaring the kids and the parents that eat here!" What could I say to that? I ran away. After a week went by, we had not heard any more complaints, so I strolled by to see what was up. The woman was still at the grill where I left her, and she waved me over with her two-pronged fork. I stayed three fork's lengths away, just in case, but there was no need. "I love the mural now. Everybody stops and takes pictures, and I'm selling a lot more food." Art and commerce work together in Coney. No, actually—in Coney Island, art is commerce. As the Coney Island Sideshow artist Marie Roberts will tell you, a fast nickel beats a slow dime. Every time.

The Dreamland Artist Club was meant to be a summer fling, but after a summer we realized

# MONTHS
## DUMPED

# YEARS
## DISAPPEAR

# HOURS
## DEVOURED

# DAYS
## SLAYED

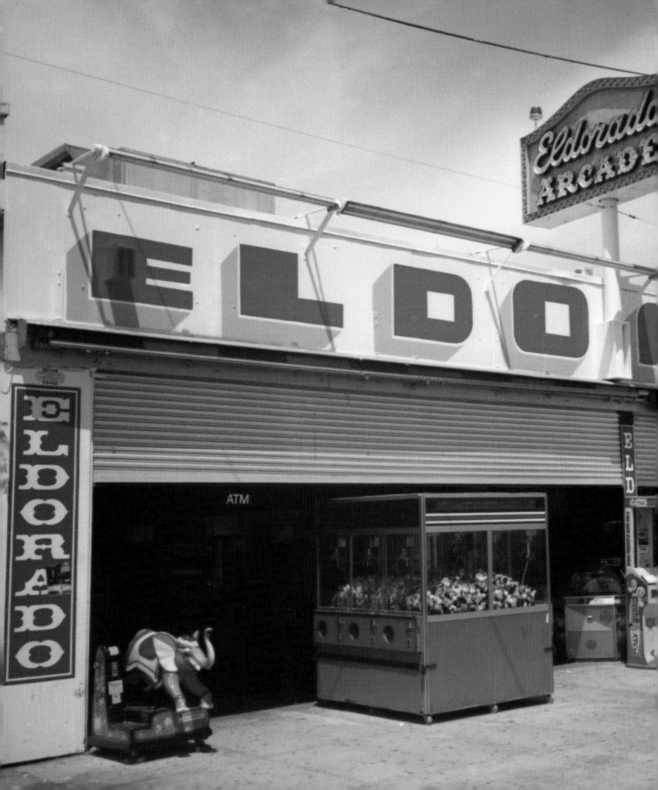

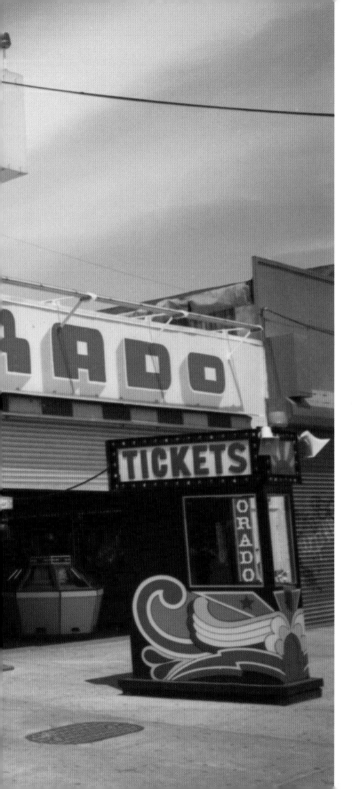

The back of the Eldorado Arcade: Painted 2003. Destroyed by seagull crap 2004. Scott Fitlin hired us and held us to a high standard. His sound system was the best I ever heard, his bumper cars the best I ever rode. He wanted the best signs. We tried. RIP, Scott.

# CURBSIDE CONFERENCE **ANNE PASTERNAK**

**Anne Pasternak**
*President and artistic director,
Creative Time*

One chilly January morning, Steve and I walked around Coney Island's amusement district looking to meet owners of the sideshow businesses that had been boarded up for the winter. We wanted them to join us in Steve's big idea of having artists paint signs and backdrops for the games, rides, and food stalls in the historic district along Jones Walk, as well as the boardwalk—a legendary site that had long been in a state of tragic decay. We knocked on metal gates, tried opening unmarked doors, and even met some of the local business owners

as they sat drinking booze in their old sedans. At every encounter, I felt a bit of a chill, and it wasn't just the weather. I realized what Steve already knew: I was a fish out of water, an alien in my own city. I fit in better with the self-proclaimed carnival freaks and mermaids than with Coney's business types.

So I left it largely to Steve to work his magic with the locals, and over time, dozens of business owners agreed to collaborate with us. They had real trepidations, but many wanted to do something positive for the community before Coney's inevitable Disneyfication became reality, and they could see that Steve's ideas might help do that. Plus, they trusted him. Trust didn't come easy with this cast of characters. But Steve showed up, listened, helped out, and always dealt with people with his charismatic sharp wit, wry humor, and honesty. He was so committed to the community that for years he ran a makeshift sign shop on the main strip, where a wide range of Coney "elites" hung out. Now the signs have faded. Corrupt collectors have even illegally bought those artist-made signs that survived the sun and heat, and most of those businesses are now closed, but Steve Powers remains an active presence in the neighborhood, keeping it real.

*Portrait by Timothy Greenfield-Sanders*

A LOVE LETTER TO THE CITY

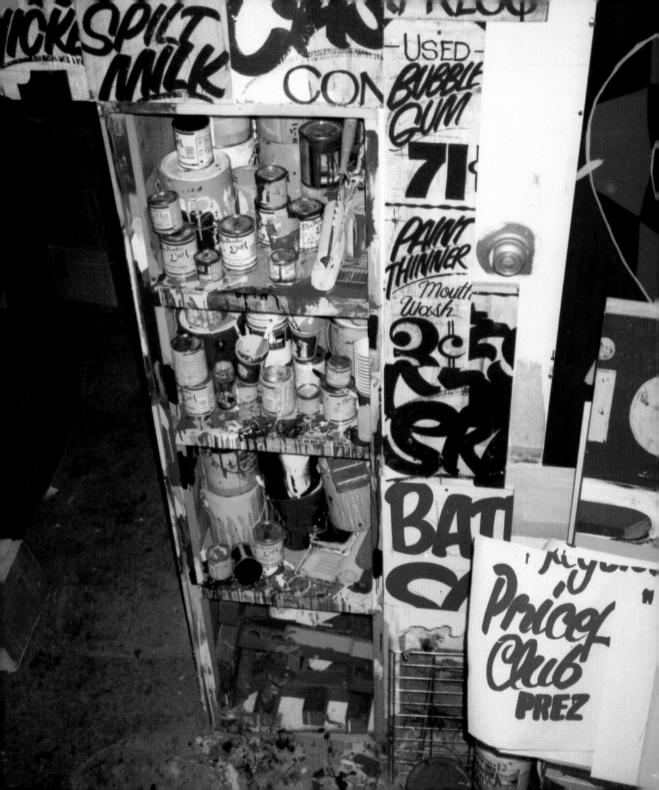

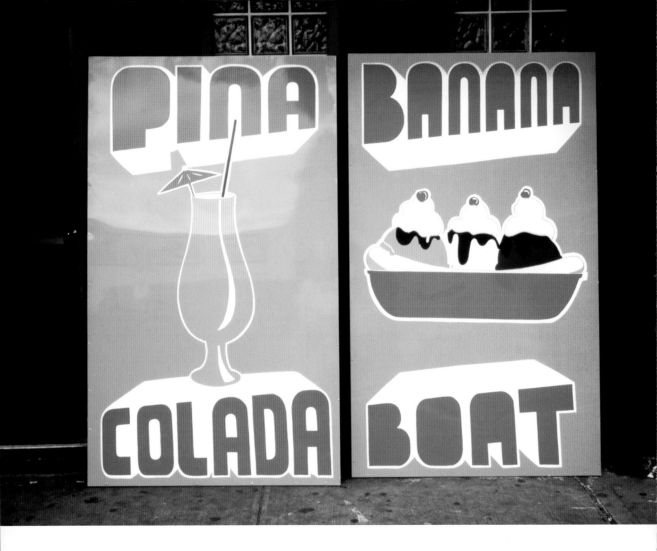

**p. 17:** Shelving and signage by Matt Wright. Except for the crummy "Price Club prez" sign—that's mine.

**above:** Two of ten signs painted for Lambro's corner. We had to haggle to get $500 for the enormous job, which I split with STAK, Greg Lamarche, Nate Smith, and Ned Vena. A week after we finished, John Lambro waved me over and said, "Boy did I rip yous off—it cost me $500 to get three little vinyl signs done." I said, "Feel free to give us a tip." He laughed.

A LOVE LETTER TO THE CITY

that there was an endless amount of work to be done, and we wanted to extend the project for a second year. Creative Time was against the idea of doing the same project twice, so I proposed giving the Dreamland Artist Club a clubhouse, a sign shop in the heart of Coney Island that would allow us to be in the community and go well beyond our sincere but outsider contributions of the previous summer.

If you want to be inside Coney, pay rent. If you want to be a Coney insider, you have to be a carny. One guy that understood this was Valentino of the Gents of Desire, an LA party crew renowned for their elegance and their successful quest in the pursuit of elegance. He took a week off from his high-pressure, high-paying day job as a Hollywood art director to participate in our venture. Valentino took up residence in our shop in Coney and taught me how to make full use of our clubhouse. He kicked back in his Louis Vuitton slippers, and in less time than it would take him to choose the right shade of blue for a movie set, made himself a carny.

### CONEY ISLAND IS STILL DREAMLAND
(to a seagull)

"Coney Island Baby" is an achingly beautiful doo-wop song by the Excellents. It was revealed to me a few months ago, washed up on my shore like a Ballantine 40 bottle with a love letter inside. We set up a stereo in the sign shop to play it repeatedly and speakers to broadcast it onto Surf Avenue during the dead of winter.

In summer 2005 there was no need for it— the aural competition was too strong on Surf Avenue, even for a piece of ear candy like "Coney Island Baby." As I stood in the doorway of the shop, to my left, two doors down at Eldorado Bumper Cars, a percussive voice slashed open the pockets of passersby with: "BUMPBUMPBUMP YOUR ASS OFF, YOU RIDE YOU DRIVE, THE LIGHTS ARE FLASHING, THE CARS ARE CRASHING...." It's a money-making mantra that even Crazy Eddie would respect. Not to be outdone, sitting right next to our door was a greasy fat man with dreads and a crushed-glass vocal, chanting, "MAGIC MOUSE, ONE DOWAR." The Magic Mouse is an inch-long plastic mouse with a thin piece of filament that you tie to a button on your shirt. As you wring your hands, the mouse seems to be running over them. The chant, the hypnotizing movement of his hands, and his toxic-hippie apparel all conspired to make people freeze, and the low price got kids to pry the paper from off their parents. The Magic Mouse man's black dress socks expanded with currency—good thing he kept his socks secured in a running-shoe safe with a Velcro lock.

While both of these barks were great, it was Valentino who put the entire block in the "gent check." He arrived on a muggy Monday, acquiring two folding chairs and a table and setting up shop out front. He placed a large bottle of bootleg Gold Bond on the table and started to chant, "POWDER, POWDER! STAY DRY, STAY FLY! BE LIKE MALCOLM AND GET SOME TALCUM! NOT DOPE, NOT 'CAINE, HOOK YOU UP JUST THE SAME. POWDER, POWDER." It performed magic, knocking the Magic Mouse man off his pitch, squelching the bumper car squawk box, and introducing a new product to the island home of illusory commodity: smoothness, dryness, flyness, all in powder form. Only fifty cents. Less than one one-thousandth of your rent.

Everyone has an emotional investment in Coney, and we value that by making work as fried, greasy, sweet, cheap, fun, and flashy as any other experience you can have there.

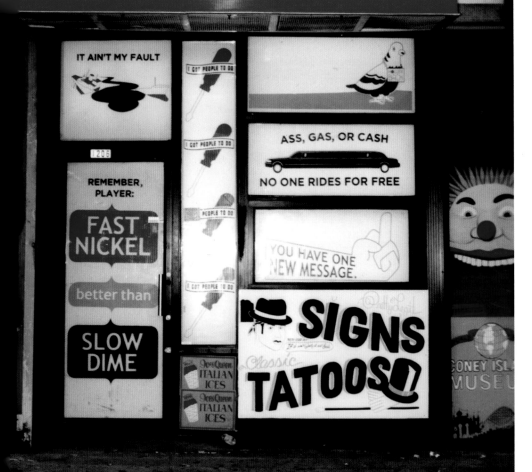

**opposite:** 1201 Surf. "Aritst." It wasn't planned,
but one out of three Coney Island signs is misspelled,
so we kept it.

**below:** That's your boy.

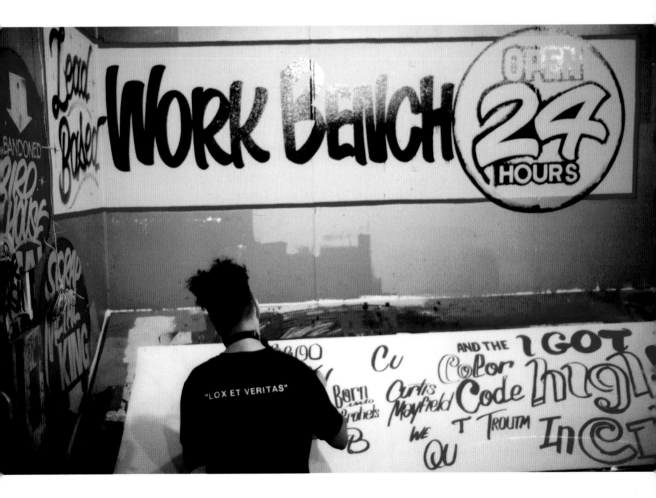

That was the moment, two months after we opened our sign shop/social club, that we finally hit our stride. It felt like we were right on time. We had created something new in a place that had literally seen it all. We were a functioning sign shop that made signs only for local amusements or for our own amusement. We accepted no commissions, made no concessions, and just soaked up the salt air and the salt attitude of the place and put it into the work.

Let me go back to the start. We got the keys on June 6, giving us twelve days to empty out the place, hook up the electricity and plumbing, and get everything to a reasonably finished look for the opening on June 18. I got a twenty-yard dumpster, and before we put anything in it, the neighbors were already putting trash in and taking trash out of it. Two interns from Creative Time showed up. One of them, nice as he was, fled when he saw us carrying out jars of piss from the deli that had been in operation there two years before. The other, Ned Vena, a recent arrival from real estate called the Real Estates, started dragging out trash like it was the latest craze.

Once the dumpster was 30 percent over its limit from a long day of detailed demolition by Lew Blum and Dan Murphy, we called in the architect, Matt Wright, and the builder, Mike (just Mike). Matt is a veteran Brooklyn sign painter—I'd coaxed him into being a partner in the shop, as long as he didn't have to talk to anybody. The deal we made was that the front of the shop would function as a meeting place for the Creative Time people, and we would paint signs in the back, in an accurate and functioning representation of every sign shop Matt had ever had the (mis)fortune of working in. So I divided the place in half and told Matt my ideas

for how it should look. Matt just nodded, and I went away for a week.

When I got back, I breezed through the door, and it was the best thing ever. The front was 30 percent smaller than I wanted, and it had a six-foot-tall counter that was pure intimidation. The wall behind the counter curved at the top so it looked like a wave of Matt's bashed-out signs were going to crash on you. Then they hit me with the coup de grâce: the counter was on a hinge so it completely swung open, allowing for materials to be moved in and out and for better ventilation. It was a surprise that P. T. Barnum would approve of. Fredini, the host of America's Favorite Burlesque Gameshow *This or That!* and longtime Coney presence, tells us that the tall counter is classic Coney: "They built them so high so they could shortchange people."

We could, but we weren't really selling product. A few people were clued in that they could buy original art from us for a fraction of what was being asked in galleries, and the proceeds from those sales would go straight to Totonno's Pizza and Seaside Car Service. Other people would try to commission signs for their summer homes far from Brooklyn, but we couldn't do it; we had too much Coney work. We agreed to paint signs for anyone who needed them within a ten-blocks radius, and we would be busy for a few years trying to do them all. The only complaint was that we usually took too long, but it was free, so nobody busted our balls too bad. Ohh, but when Coney carnies do break your balls, they stay broke.

Scott from the bumper cars looked at a sign I was installing on his ticket booth and said, "This stinks." I was revving up to protest when he waved his Kool in my face: "Nah, listen. I have lugs on my bumper cars that have to be

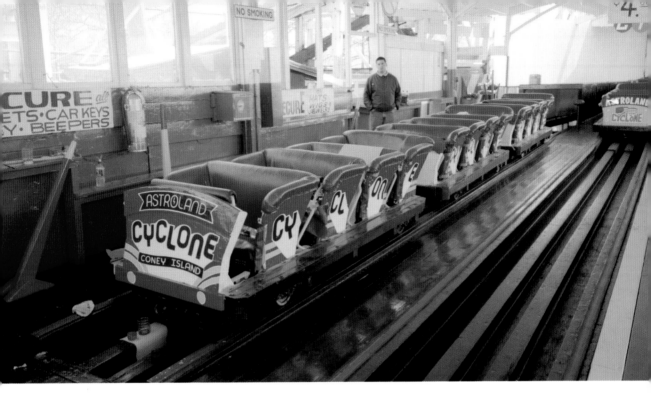

**top:** That guy was rushing us to leave. EVERY single day.

**bottom:** Matt Wright sign. I got a lot of free tries. I never won.

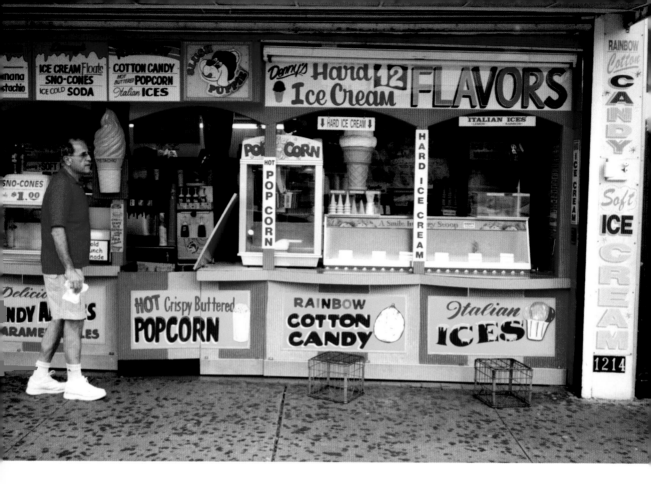

Denny and his ice cream shop. Our contribution to his
already excellent signage was the "Hard Ice Cream 12
FLAVORS" sign by Valentino.

A LOVE LETTER TO THE CITY

torqued to thirty-two Newtons per meter. None of this pounds-per-square-inch shit. They can't be twenty-five, they can't be forty, they gotta be thirty-two." At this point I was looking at every flaw in my work and wincing in embarrassment. I replaced the offending work a week later. When he came out to look at it, he said, "Thirty-three, maybe thirty-four....Oh, well, whatever." I took the abuse gladly. This was Brooklyn, after all. What doesn't kill you makes you.

The Dreamland Artist Club was about providing service to a really special place in the world. Coney Island is a place that's been weary and worn for most of the last century, but it has a beauty that remains, in spite of arson, poor race relations, and developers and city officials vandalizing the place. It's our summer home; it's the place we let our guard down for an hour or so; it's our common denominator. Everyone has an emotional investment in Coney, and we value that by making work as fried, greasy, sweet, cheap, fun, and flashy as any other experience you can have there. Soon, they are going to turn Coney into a concrete-covered Styrofoam mall, like the crappy ballpark they built over the Thunderbolt roller coaster. You can't blame us—we'll be part of what they will kill. We stand for the low-down, the fast one, the carny's patter as you pass, drinking in public, shooting the freak, Eak the geek, Mayor Dick Zigun, Together Forever, the guy with the snake, his man with the macaw, the break-dance gangs (both of them), and partying under the boardwalk. All that is going or gone. We worked hard at appreciating it while it existed: our work is sworn testimony.

Valentino lit a Lucky Strike and worked on his flash. A skeleton with a Fred Perry shirt and a hat with a stingy brim holds a blackjack.

Another skeleton is wearing a V-neck sweater and holds a pistol. A third is in a mod suit and wields a knife. There are maybe a dozen designs more: The hooded sexecutioner with an axe and a lightning bolt. A peckerwood genie (essentially a white guy with a mullet, moustache, and shades) rising from a magic lamp. Some *chicas*, some scripts, and some crosses round out your choices. If you want something different, you'd better be an extraordinary person with an extraordinary vision—otherwise you'll take (gladly) what's offered. Most of the designs offered were taken, and the price of Valentino blessing you with his vision was five to thirty-five bucks.

I tell him that there are Bloods and Crips in Coney, and he says it would be great to tattoo "Boney Island" on a Crip. Before the sun sets the next day, he's got a do-ragged youth named Eric in his chair, claiming "Hoover Crip." Not only that, he's got a cousin that's a Blood. He says they shoot at each other, but they're family, and they hang out. It's Coney Island, after all, and the place gets boring without friends. After about thirty seconds, I realize Eric is the most important person we're going to impact here. And Valentino, scion of Southern California—a place whose abundant cultural resources include gangs of stoners, *cholos*, and Popsicle vendors—knows exactly what it means to carve an identity for yourself out of your neighborhood. So, Extraordinary Young Boy and Old Head with Extraordinary Vision collaborate on art for the most endangered place in Coney Island: the chest of a seventeen-year-old gang-banging black youth.

The tattoos Valentino blessed Eric with were authentic manifestations of the ballpoint gangster drawing style you'll find in classic issues

of *Teen Angels* magazine (Valentino brought a short stack of *TA*s east with him). His tattoo gun is an official jailhouse tattoo setup: Walkman motor and a guitar string, powered by D batteries in a paper-towel roll. But Valentino himself is the most official and authentic adult Eric is going to cross paths with anytime soon. He's a self-made Mar Vista myth, born of a misspent youth and carefully constructed adulthood. He's a Gent of Desire, the living memory of the "Touch of Class" look, a wholly American style born in complete poverty and dereliction. It's the product of aspiration and inspiration; its designation is the top hat, the white gloves, and the cane. These three items together form a symbol that you can find heralding the high life in every run-down city in America, and Valentino has codified the look into seven laws that Gent initiates are required to uphold. The best part is that true Gents of Desire are already living the Dream; Valentino just puts them on the team.

Eric is such a Gent. Actually he's a Boy of Elegance, which is a purgatory for Gent prospects. In any case, even without a membership card, he's already living up to several of the laws: he's projecting the fantasy (#1); he'll run up or shut up (#6); he's not half-steppin' (#5); he suits up and shows off (#2); and he'll never go back (#7). The rest will manifest, as you will soon see.

So Eric gets tattooed, and he gets invaluable insight into a sustainable model for his adulthood, if and when he gets there. In the course of the week that he's in Coney, Valentino yells at Eric, boxes him, lends him smokes, challenges him to a push-up competition, and meets his family (older sister–slash-guardian-slash–backup plan), all while holding a street-level

ways-and-means-committee meeting. He never tells him the obvious; Valentino just provides an example for consideration.

How do I know lickle yout learned him lessons? A week after Valentino departed, Eric came through, looking for a hookup. He said, "I need to hustle some money—can I see some powder?" Every day since Valentino had left, I'd put out the folding table with the Gold Bond powder and the sign advertising it. In the week Valentino was selling powder, no one took him up on his offer. Eric went out and sold ten pours in ten minutes. Valentino had the right product and the right pitch, but he was the wrong pitcher. Eric stepped right in the path of people and told them true, "You, this is that smooth," and—presto—he got that change-o. The top hat, the cane, and the glove work magic again, turning a boy into a Gent.

Valentino and friends

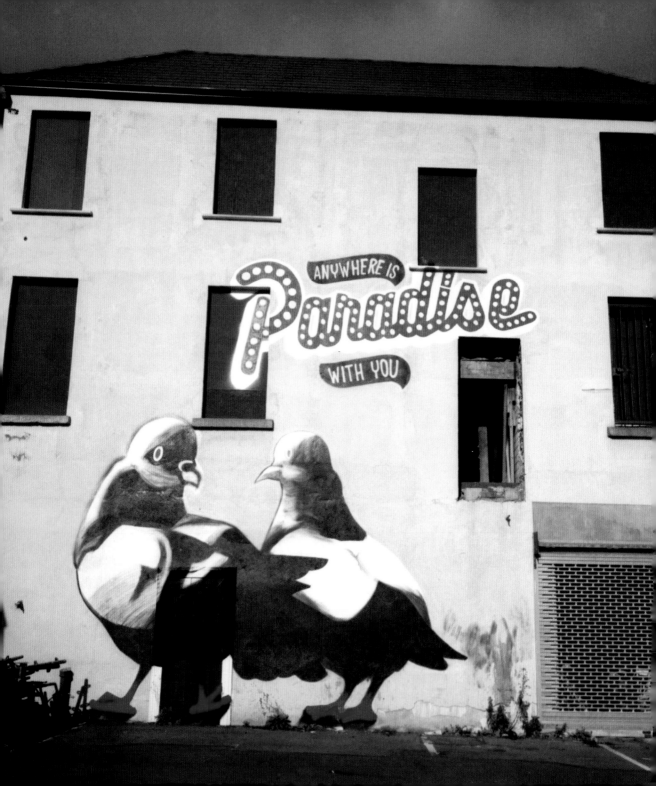

# DUBLIN & BELFAST

Dublin is a small town, but has more vitality per square meter than any city twice its size. In the early 2000s a lot of cultural initiatives were happening there, and at the forefront of most of them was a curator named Declan McGonagle, who had seen a piece I had created for the Liverpool Biannual in 2002 and had arranged to have it installed on the City Arts Centre in Dublin. Declan thought the work, installed on the outside of the building and facing a major intersection, was perfect for catching people in what he calls "the third place" (the first two being home and work, the third being your commute). He believes the third place is ideal for showing people art, when their attention is up and their guard down. Since I do all my best work in the third place, I fully embraced the idea, and it has become a part of my vocabulary.

Pigeons mate for life, so they make sure they pick a partner they are coo with. Painted at the Tivoli Theatre. That moniker on the lower right is courtesy of painting doyenne Mimi Gross—she invented that when she was three.

Working alongside Declan was Ed Carroll, who tapped a hundred shoulders to introduce me to everyone he thought I should know in Dublin. The last shoulder that Ed tapped on my behalf belonged to Professor Brian Maguire at the National College of Art and Design. He nominated me for a Fulbright award, and after eight months of watching my in-box, I got the email saying I won.

The Fulbright grant enabled me to travel from New York to Ireland to paint a series of walls in Dublin and Belfast in 2008. It was a remarkable time. I had recently become a father, and possibilities started emerging everywhere I looked. The objective of my Fulbright project was to paint with Irish youth, so the first thing I did was go to All City Records, a music and art-supply store in Temple Bar, Dublin, to get a bunch of spray paint. I also found the Irish youth I would collaborate with: the FOES crew, a group of graffiti writers who were in their usual positions holding up the walls of the shop.

Originally, I was going to do paintings about two fictional characters who were trying to find each other and love each other, and I thought it would be great if they were sending painted messages back and forth, but I really had no idea where to take this. Then, the first day I got to Dublin, I saw the most amazing graffiti near Christ Church Cathedral in Dublin's Liberties section that said, written in correction pen, "Please call me, I am home, the door is open," and it had a phone number. It was written all over the neighborhood and was pretty much exactly what I had imagined in an art context. It had already been done, and so much more effectively—by two people actually trying to connect with each other—that it rendered my attempts moot.

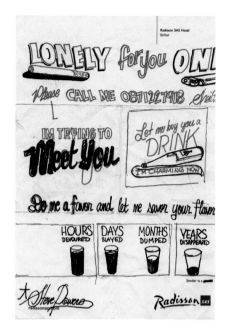

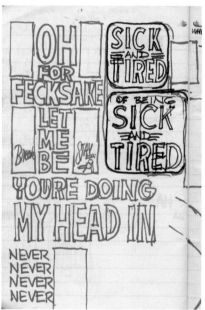

A LOVE LETTER TO THE CITY

**above:** The Garda were on the scene within ten minutes of me writing this. I was already headed to the boozer.

**opposite:** Sketchy on the details. The Radisson in Belfast is nice—half a block from the boozer.

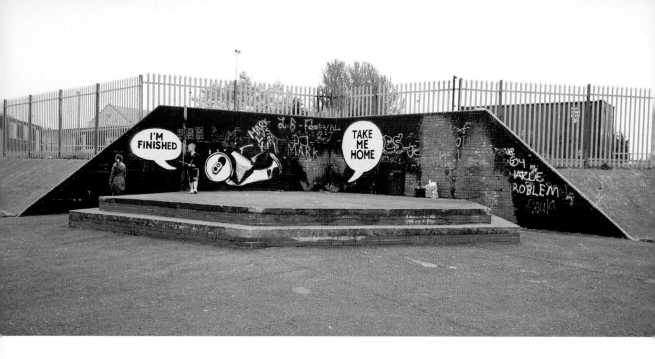

34

**opposite, top:** The bandstand in the Lower Shankill, Belfast

**opposite, bottom:** I got some death threats and some marriage proposals. Shout out to REVS, who did the phone number thing first.

**below:** Sketched on the DART train from Dublin to Dún Laoghaire. Those are notes on the mating of pigeons, rendered kind of filthy by the crop. I'm also looking for a place to kiss the son goodnight. Say hello to Malcolm and Maryanne.

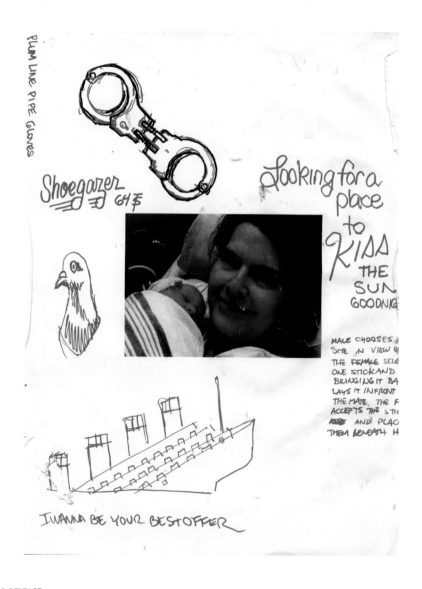

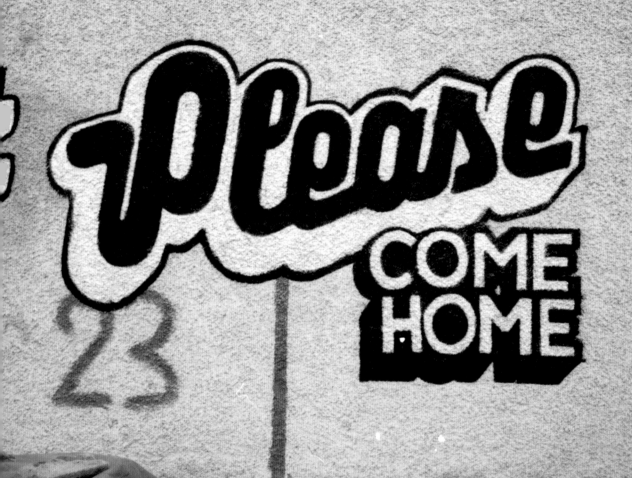

So, hitting the reset button and trying to take stock of what I could do, I realized that I had my own life and personal dramas to draw from. I had a six-month-old child at home, and I was traveling back and forth, dealing with leaving and returning. So, on the back of the Bernard Shaw pub in Dublin, I painted, "Baby is crying—Rent all spent—Car got towed—Lost the remote—No hot water—Fridge is empty—But I ordered food—Please come home." Titled *Baby Mothersday*, it describes a very New York version of wanting your loved one to come home—it isn't quite a home until both people are there sharing it. It was painted in black and silver spray paint—the original elements that I had used as a kid, trying to figure out at seventeen what expression meant to me. But at the same time, the perspective is that of a forty-year-old person who has responsibilities and is trying to make sense of life and trying to make art of it.

Ed Carroll (again!) secured me a grant from the Irish Youth Foundation, and I got my hands on a large scissor lift, which allowed us to paint a huge wall on the side of the Tivoli Theatre in the Liberties. The wall, like my paintings, depicts several emotional icons, each involving an epiphany or a query about love. All together they form a mural I titled *Signs Your Relationship Is Thriving*. The wall was quickly done, like the work I did as a kid under duress, and is a screenshot of my mind, with ten things going on at once. And again I used the basic elements of roller paint and spray paint. In painting with the same tools the youth use and painting in a similar fashion, I was making a point of showing a way of growing up with graffiti.

Everybody I painted with in Dublin was fully confused at first by the work we were doing. I had the confidence that I was on to something, but I was not sure if what I was doing was having any effect on the FOES crew. Six months after I left, I found out that one of the crew had gotten a gig with renowned poet Damien Dempsey. He was painting Dempsey's poetry in the streets of Dublin, in a style similar to mine. His friends were appalled that he was ripping me off, but I disagreed. At worst, it was like an employee taking pens from the supply closet. At best, it fulfilled the promise of the Fulbright: to instill new ideas and watch them take root and flourish. I was amazed to watch it happen.

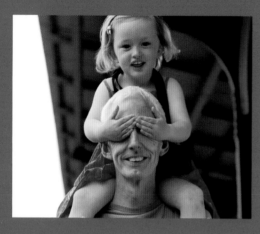

**Ed Carroll**
*Arts programmer, Kaunas, Lithuania*

Steve's Fulbright scholarship on the island of Ireland is a short story—and, importantly, part of a longer narrative that began sometime in 2002. In that year, *Waylon Saul* (Steve's series of aluminum signs, which pictorially narrated exchanges between the fictional Waylon and his correspondent Saul) came to the Liverpool Biennial. I was working with Declan McGonagle, Alexa Coyne, and a few others to program a two-year inquiry into the role of art in society. We sought out artists like Steve Powers who felt that art was not just something for Sundays.

Steve actively participated in our work and also in the documentary we produced (which can be viewed online at http://vimeo.com/4780943). Niall O'Baoill, a community-based artist, also linked up with Steve to orient him to the narratives of young teenagers who were using art and culture as their homegrown tactic to build resilience in the face of drugs, violence, and poverty.

Steve's distinctive practice draws out the narratives of street life, its people and places. You see it in the Fulbright work in Francis Street, Dublin, and Shankill Road, Belfast. *Call Me, We Need to Talk, Hope This Finds You Well*, and *Worth Less* are all fragments of exchanges among strangers, yet somehow intimate, too. The Fulbright project conceals a longer story from the creative community bench. This story is a testament to friendship and the time it takes to create a local ecology for a little epiphany of beauty.

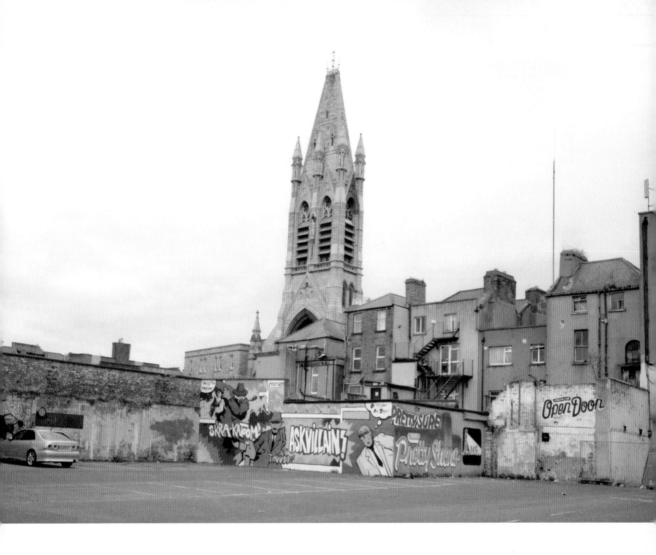

On the left is a wall that FOES painted for Madvillian,
and on the right, two of my pieces. There's a visual
continuity between their graffiti and my writing that even
now is a relief to the eyes. Wheat pastes and stencils
never jibed with graffiti—well, except with REVS, but you
aren't him.

The permanent temporary home of graffiti, the blue construction fence. Almost perfect, except "Victor seeks comer" should have been "Victor seeks loser." Garda came right away for this one, too, but too late. I was done and already getting my hair did by KONK.

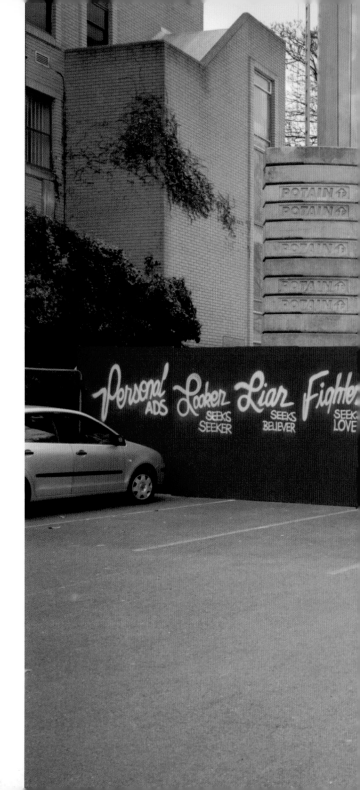

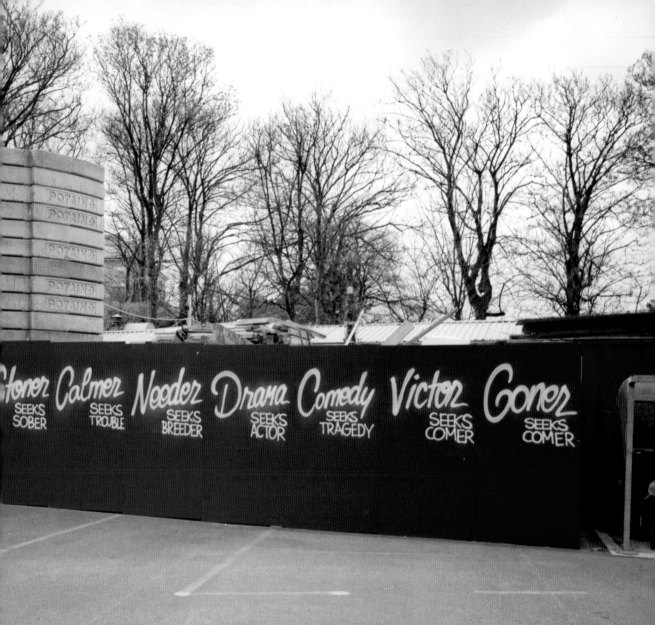

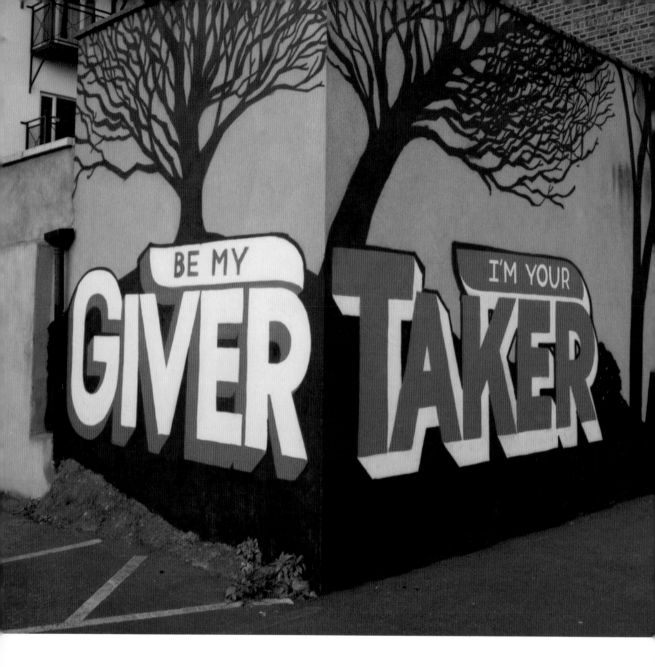

A LOVE LETTER TO THE CITY

**above:** Signing in at the job site

**opposite:** When you see DJ Krystal Klear, ask him to do his impression of me. He'll say in a singsongy voice, "You're my giver, I'm your taker!" while grabbing his ankles. It's pretty spot-on.

**right:** I wrote Open Door 64 as a backup name years before I discovered it's a great Bible quote (Revelation 3:8) and a useful metaphor for being there for those you love.

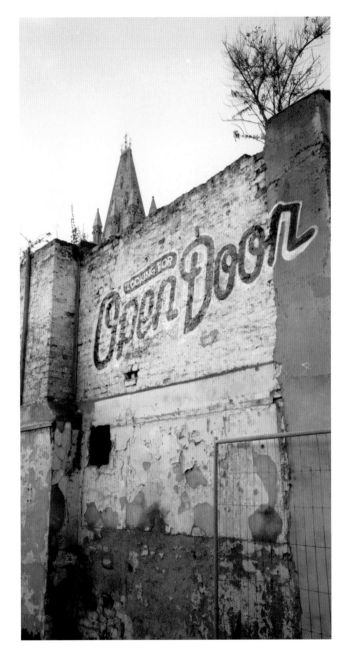

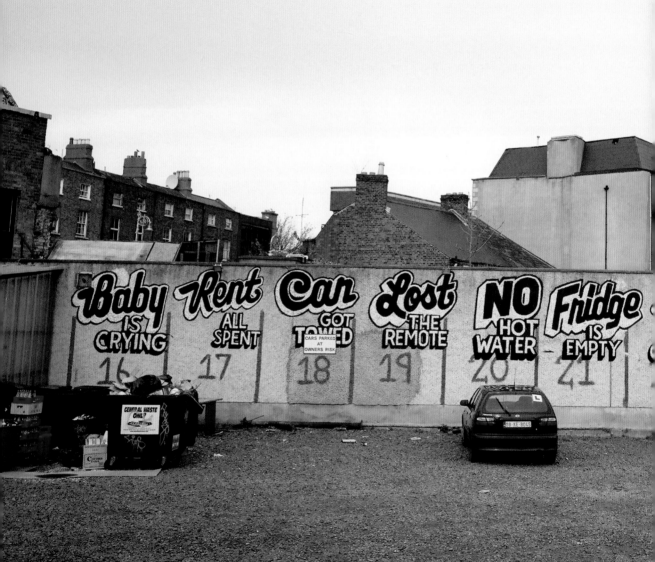

That wall surface is called "pebble dash."
The only people who like painting it are
graffiti writers. We. Love. It.

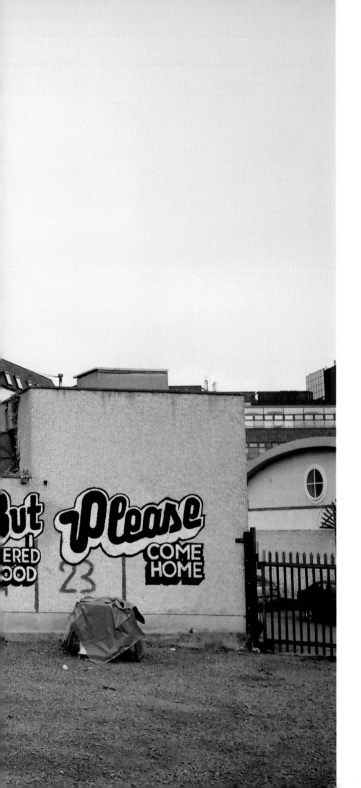

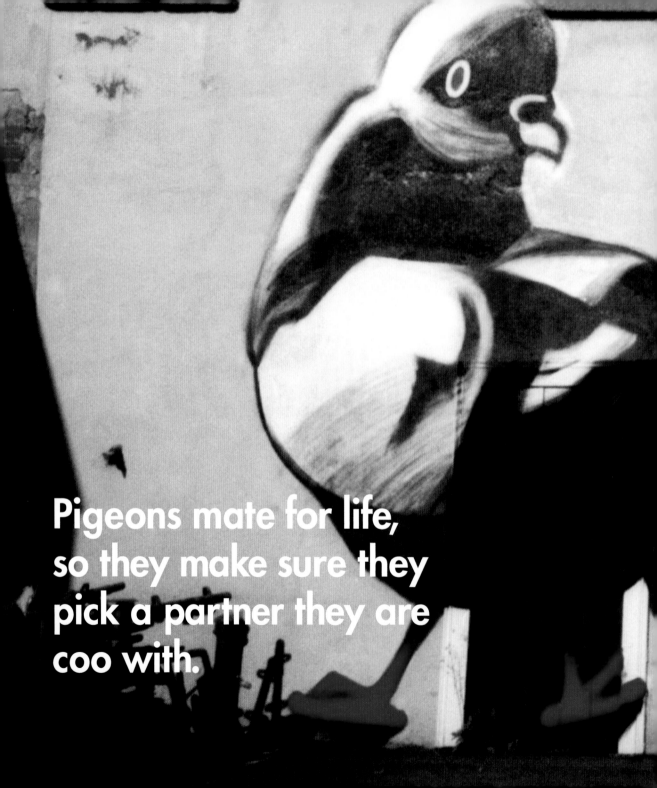

Pigeons mate for life, so they make sure they pick a partner they are coo with.

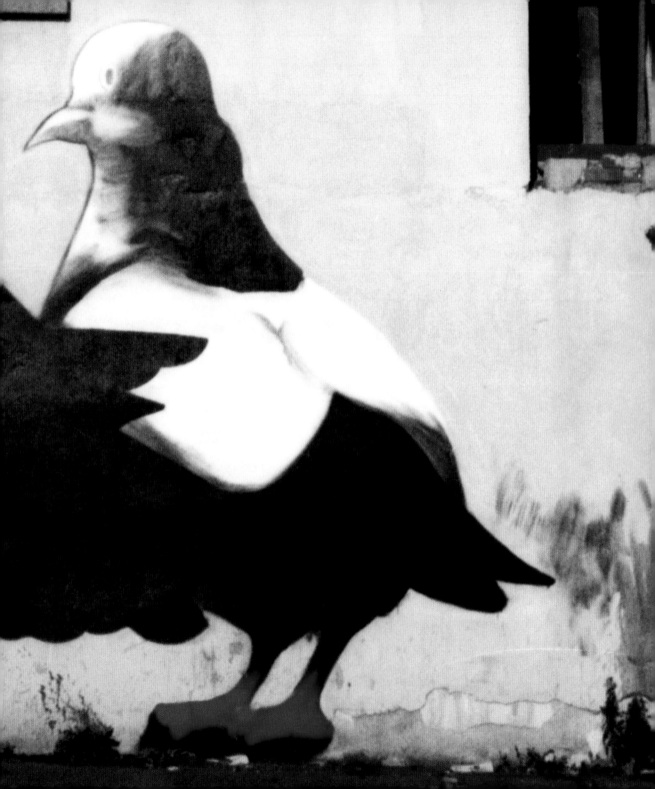

**opposite:** Opposite the Tivoli Theatre. Twenty-four-hour manned security in operation. Hopefully the surgery was successful and they will be back to doing nothing soon.

**top:** The light of my life

**bottom:** This is slang for snogging, so it's said.

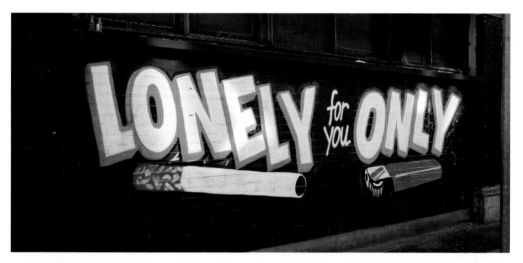

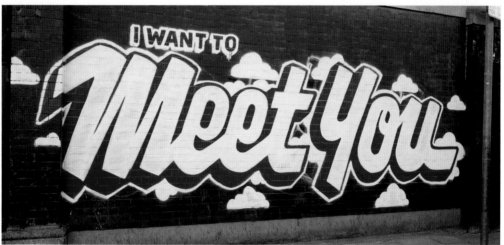

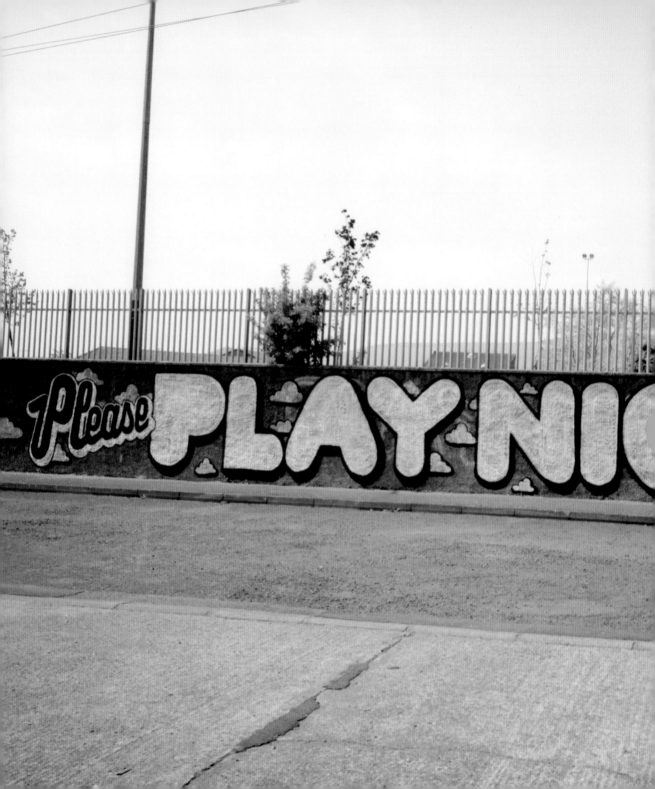

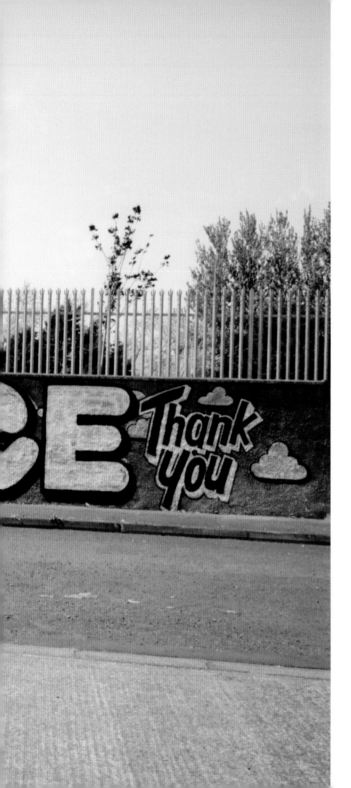

This wall faces a row of houses that I watched for any sign of life for a half an hour, while kids from the local school trooped past. Finally, a woman popped her head out of one of the homes, and I ran across the street and asked her what I should paint. She said, "Tell them to play nice." Done.

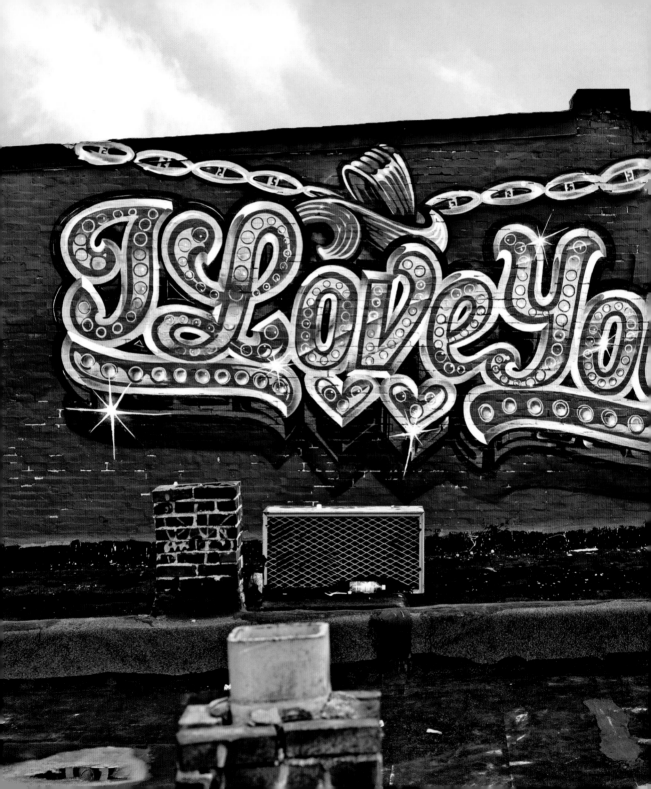

# PHILADELPHIA

The work I painted in Ireland for the Fulbright went into an application for a Pew Center for Arts and Heritage award. Every year the Pew grants a select group of artists and organizations money and the ability to make great things happen. Paula Marincola is the director, and I have been fortunate enough to have had a dialogue with her. I proposed my idea for a *Love Letter* project in Philadelphia, and she countered that the only way I could possibly win a grant would be if I teamed up with the Mural Arts Program.

Zoe Strauss photographed a woman on Fifty-Second Street who was wearing this gold chain. We (with permission) snatched the chain, and it was painted up on Sixtieth Street by SEVER and EWOK HM MSK.

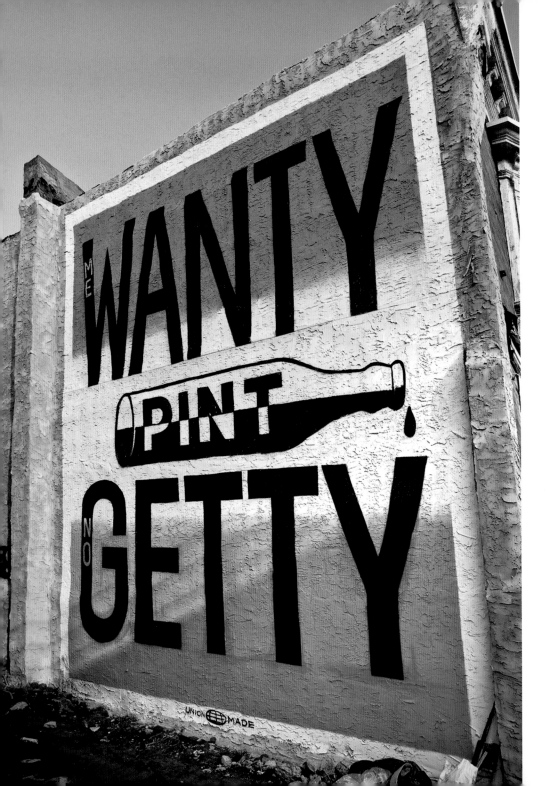

ME WANTY PINT NO GETTY

UNION MADE

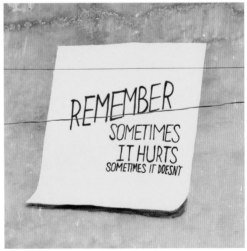

Mural Arts had never before been invited to write an application for a Pew grant, and now their best hope of winning one was joining up with an unrepentant vandal who was still dead set against the way the program made art. Paula told me, "If you win, it has to be a genuine collaboration. You have to stop being the lone wolf, and Mural Arts has to make real art." Suddenly, difficulty entered my dream, with a rolling suitcase and an eye on the couch.

We won the grant, and difficulty moved in for good. At my first meeting with Mural Arts' Jane Golden as Pew grantees, I laid out my vision for the look and feel of the project. Jane stopped me and said, "You mean it's going to be all words? No pictures?" I dug in. "No pictures." Jane crossed her arms like she was tying her oxfords and, once tight, told me, "You have to sell the idea to the residents of West Philly, one community meeting at a time." I could feel the fear building in me, but I remained cool and asked, "How many meetings?" We had about nine months before we were to start painting. Jane thought ten meetings would do it. She then assigned me a handler who also had disconnected roots in the community, and together we started planning meetings.

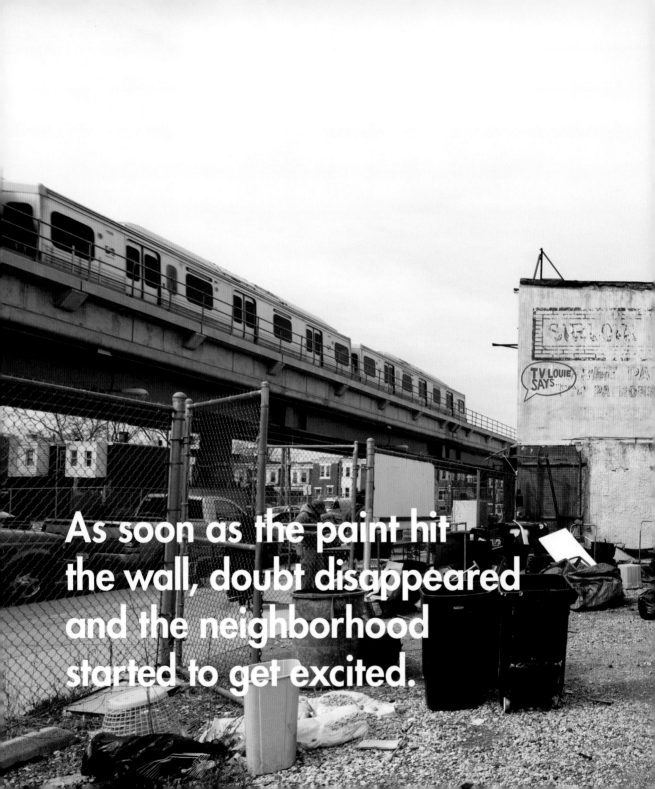

As soon as the paint hit the wall, doubt disappeared and the neighborhood started to get excited.

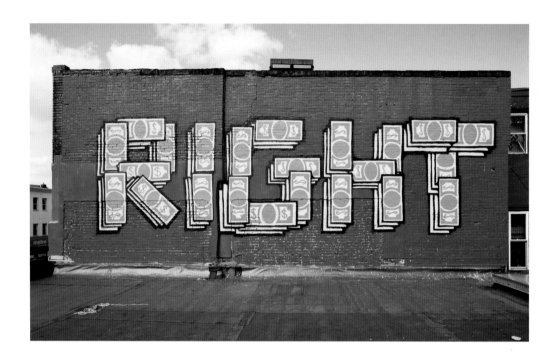

**previous spread:** As Dan Murphy and Lew Blum were finishing, TV Louie, proprietor of TV LOUIE's We Buy We Sell store, came out and said, "Put 'TV Louie says' up there." We provide good stewardship of these walls when the residents take ownership of these walls.

**above:** No romance without finance. SKREW MSK got the money right.

**opposite:** Take one, before it got buffed by Anti. Tips for Toys #1: Buffing it will only make us do it better the second time.

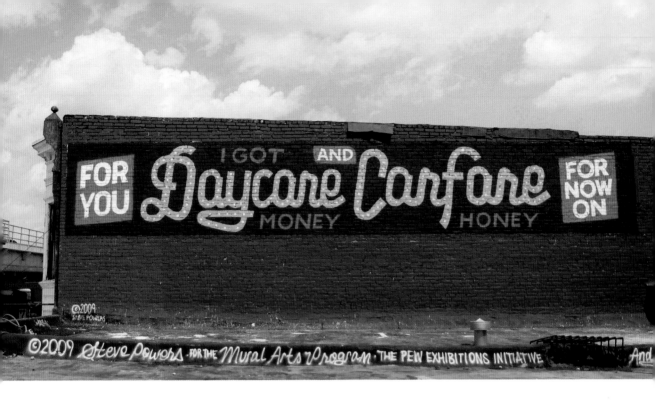

© 2009 STEVE POWERS

© 2009 Steve Powers · FOR THE Mural Arts Program · THE PEW EXHIBITIONS INITIATIVE · And

Jane's methodology is flawless: go into a community, tell people you are going to paint a wall, take suggestions from everybody, work up a sketch, go back to the community, show it to everybody, make changes based on the suggestions, then paint the wall. The art is secondary to bringing the community together and getting everyone to agree on something. The wall stands as testimony to a unified community, even if the artwork is completely boring.

I'd spent all my life working in counterpoint to this, so I wasn't sleeping well when I faced the fact that I was going to have to do this Jane's way. The first meeting was a scripted affair that outlined the project and invited neighborhood residents to give us suggestions. I said a few words but was kept to the side as

a professional mediator fielded comments and nudged the crowd toward consensus. It was a perfunctory meeting, just vague promises and vague dialogue. Jane let me know it was only to lay out a template for me to work from. "You can run ten meetings like that, or you can realize the potential for engagement. I know you won't let me down." At the second meeting, I began talking more and really started to verbally sketch out what I wanted to do. I also started saying, "The best idea wins." The Handler was alarmed. "You can't say that—you're supposed to be getting inspiration from the community." I was, but I was also challenging the community. Handler crossed her arms like she was lacing up her Timberland boots and started working against me. At the next meeting, in a storefront church

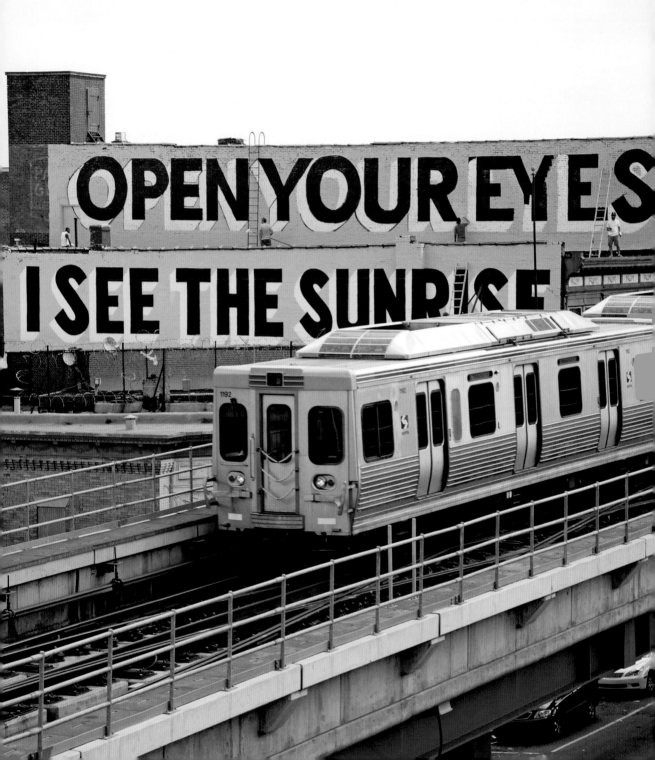

**opposite:** Who's that goldbricking on the left? I won't put him on blast.

**next spread:** Thank Jah, Philly is the kind of town that respects the shortcuts, like the one our neighbor is taking here. New York City would put a lock on that gate. STAK and Greg Lamarche handled the *Home* wall. In addition to Michael Jackson, they put graffiti godfather IZ in the pile of refrigerator magnets. Rest in peace and piece to the two of them, respectively.

that might have held thirty-seven, a contingent of women from the block association filed in and took three rows of seats in the back. I didn't even present my proposal—I just opened the floor to questions. Instantly, every single member of the block association asked me a two-part question simultaneously: How much money is being spent? How much are you getting paid? Why is the city spending money on art and not the sidewalk? Why wasn't that money going to the playground up the street? Is this propaganda for SEPTA [the Southeastern Pennsylvania Transportation Authority]? Are you working for SEPTA? Why are you coming into our neighborhood with this? Why don't you do something about the drug dealers? When can we see drawings? Why aren't you doing more for the youth of the neighborhood? And finally, Who are you to speak for us?

I'd been watching the Handler since the questions started ricocheting off the walls, and she'd maintained an unbroken stare into her phone. Finally, she rolled out of her lean against the back wall and stepped outside. This is it, I thought: this is when it all goes down in flames. But the fear dissolved and resolve took hold. I tabled all the infrastructure questions that were way beyond my scope, then worked through all the questions that were within. I closed with a short explanation of my motivation. "I'm from Sixty-Third Street, and that's only a walk from here on Sixtieth Street. Regardless of where you live, we are all here because of love. The love I put on these walls will speak to your sons and daughters in a way that no one else is speaking to them, and even if they have no love in their own lives, they will know love exists." One of the women in the back asked, "Yes, but why here?" Caroline Bardwell, who led the group, sighed and said, "Because he's from here." The Handler returned to the meeting to see us all eating pizza, building a consensus bite by bite.

The meetings refreshed my understanding of the West Philly mentality, and opening a sign shop at Farragut and Market Streets made me a vested community member. I started knowing names and faces. I started getting stopped on the street and receiving phone calls looking for work for nephews and sons. One woman burst into the shop, saying, "I thought you said you had ex-cons working here!" I asked the ex-cons in the room to raise their hands, and five went up. There was still suspicion that I wouldn't follow through on my promises, but I earned a reserved "We'll see" from the neighborhood.

Regardless of any doubt, I felt my roots reconnecting, and I was drawing on the strength of home. The closer I got back to the neighborhood, the more I could see fractures along parish lines or numbered cross streets, even block to block. The divisions mostly had the tenor of sibling rivalries and were more interesting

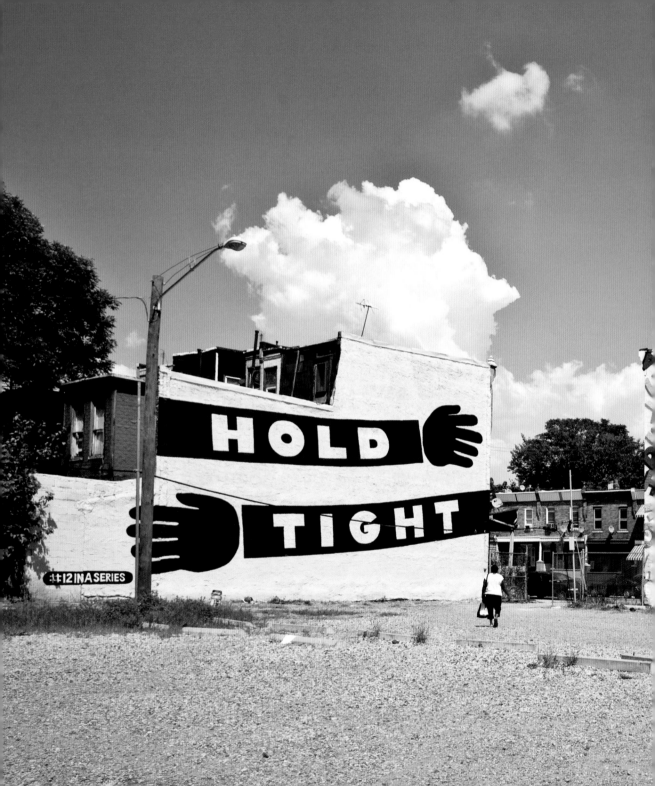

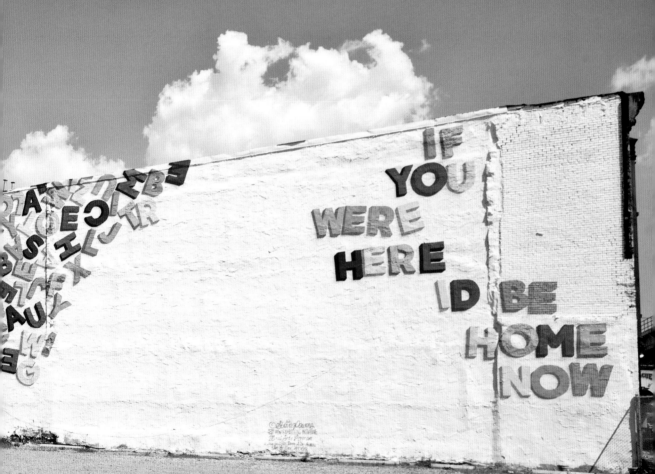

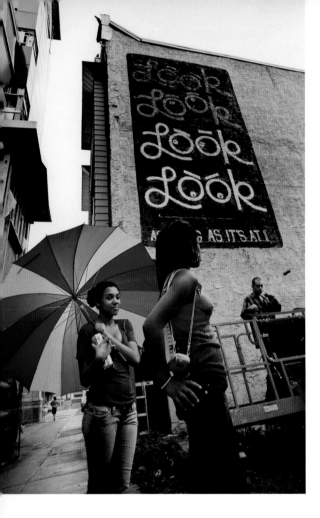

**above:** Primary colors, primarily, up on Sixty-Second Street. Pat Griffin made this look good. I think Darin Rowland and Lew Blum looked out, too.

**opposite:** This was the first time El Josh used spray paint to draw something. Those phones turned out good, huh?

than distressing. But they meant that as we met with groups more than a few blocks away from Market Street, we'd have to navigate the anger felt toward big sister Market Street, who always got all the attention. Ten meetings, it turned out, were not enough, so we added a few more at the farthest edges of the neighborhood, the last of which was punctuated by two attendees standing and yelling, "This ain't Market Street, this is Haddington!" Then they stormed out.

We finally reached the day when it was time to start painting, and Jane sent me to one last meeting, with the Mural Arts Program Design Review. A meeting with the Design Review board is standard for every mural project, and I was warned that if I didn't pass muster, Design Review would hold up the project until it was satisfied with my community work and the artistic direction I was taking. At this point I had only eight walls planned out, and the remaining forty-two were unknown quantities. I made my case right from the start: "I have to create the work as I go: block by block, wall by wall. I want to allow myself the inspiration I will get when I'm out on the rooftops and I'm ready to speak in the voice of the community." The three-person panel was two-thirds uncertain of my approach. The remaining third, Parris Stancell, a muralist who had the longest history with the program besides Jane Golden, ruled in my favor. "I believe that's the only way to do it. I look forward to seeing what you speak." I had the panel's blessing to go back to West Philadelphia with a thousand cans of spray paint and eight hundred gallons of bucket paint, to repaint the very rooftops I had painted as a youth.

A LOVE LETTER TO THE CITY

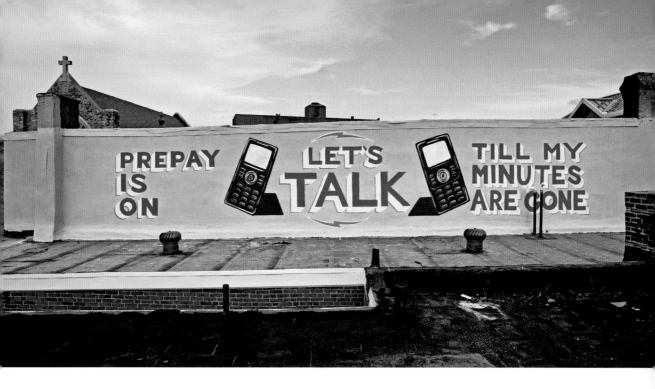

As soon as the paint hit the wall, doubt disappeared and the neighborhood started to get excited. We started painting the day the news broke that Michael Jackson had died, and as we were whitewashing the wall, people kept coming by, saying, "You should do a glove up there." "Do Michael Jackson moonwalking up there." We were painting a jumble of magnet letters as if they were stuck on a fridge, so we tucked "Michael Jackson" into the letters, starting with a blue *M* at the top of the roof. As soon as the letters were in place, I would point out MJ's name to the people who asked, "Why aren't you doing something about Michael?" When they saw that we had and that their suggestions had been heeded, they took ownership of the wall. The power of that ownership went far beyond anything I had created up to that moment, and

community ownership became the goal of every wall we've painted since that moment.

After a week of painting, Jane realized we'd painted thirteen walls she had never even seen sketches for, and she called me up and demanded to know why I was painting out of the Mural Arts loop. I told her to come out to West Philly to ride the train with me, and if she objected to anything, we'd paint over it. The following morning, on a bright Saturday, Jane and I met at the sign shop and rode the train in a cool silence. I pointed out every wall and told what had inspired each sentiment. When the last wall was passed, Jane exhaled and said, "OK, it's really good. I get it." She sounded the same note of acceptance as she had when I'd shown her the photos of the *Mona Lisa* wall in 1987.

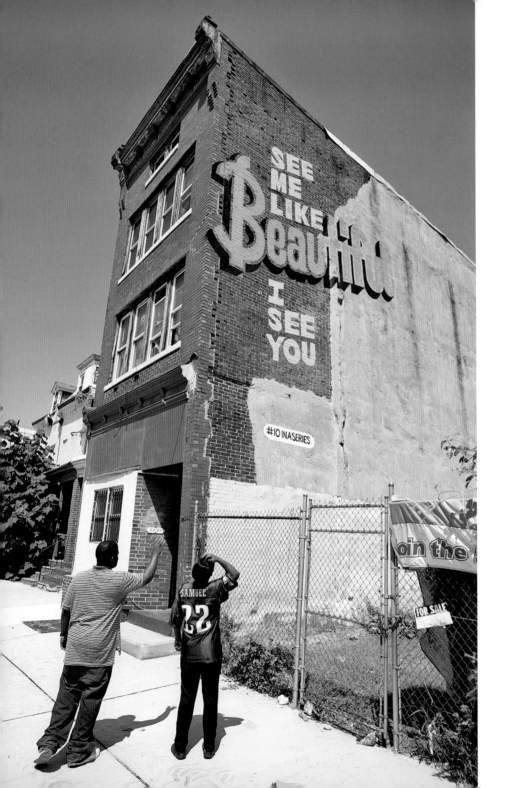

**opposite:** SEVER is a beautiful man. Shout out to the lady who asked, "Why's it say 'See me like beautiful I see you?'" It's no typo—no typos in art.

**below:** *Megawords* magazine continually features the phenomenon of staggered buff marks that occurs in Philly when Anti can't be bothered to match paint on successive buffs. SKREW MSK painted my vision. He doesn't like how it turned out. Oh, it's alright.

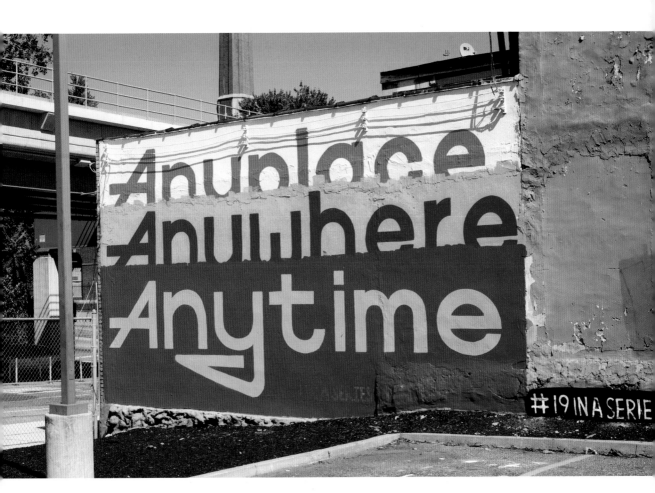

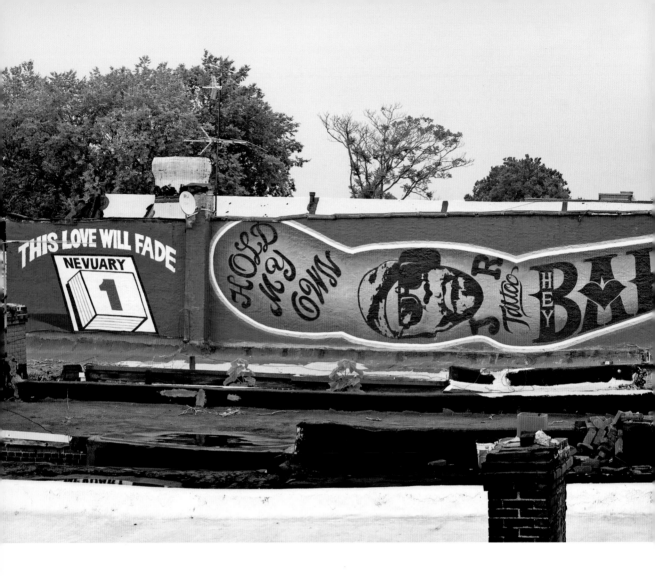

Allen Iverson's arm. Iverson was an early adopter of
tattoos in the NBA and a personal hero of mine for his
legendary "practice" press conference. We kept the best
tattoo he had ("hold my own") and replaced the others
with our own designs. Since the roof is property of the
Wheels Of Soul motorcycle gang, we paid tribute to their
beloved former leader, JR. RIP. When on Market Street,
visit JR's Tattoo for all your tattoo needs.

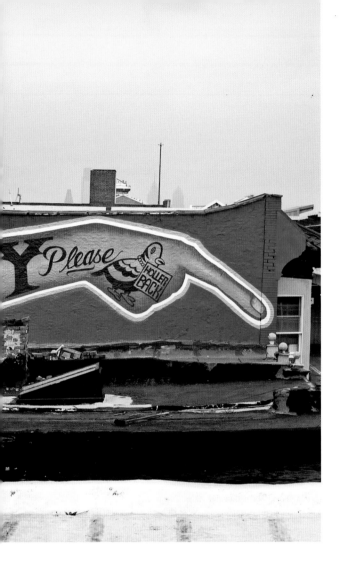

With Jane on board and the neighborhood excited, our train of thought went express. We started painting bigger and more aggressively. One building on Farson Street, a calamity of concrete and broken windows, got tackled with type across two stories. We knew we were really pushing graffiti into the equation here, and I waited for the complaints, but I never heard a discouraging word. A few years later, the building was for sale and was written up in the Philadelphia real estate press as a unique opportunity to own a piece of the *Love Letter*. It was a mind-boggling reversal of fortune for the graffiti writers who worked on the project. Once, what they had painted was charged as thousands of dollars in damage; now it added thousands of dollars to the asking price of a property.

We had several amazing curbside conferences. The best occurred as I was painting the Post-it Note wall at 4915 Market. I was writing "Remember the good" and had gotten as far as "Remember" when a woman walked by and asked what I was going to write. When I told her, she said, "No, that's terrible." So I came down off the lift and asked her what it should say. She replied, "Remember, you can always get divorced." I said, "That's terrible, too." We both laughed, and she said, "Ask one of these kids what it should say." Right on cue, a twelve-year-old named Nassir appeared in front of us, and I asked him what he thought. He thought for exactly one second and said, "Remember, sometimes it hurts, sometimes it doesn't." Perfect. Nassir rode off on his bike, and I thanked the woman for her intervention. I asked her how close she lived, and she said, "Oh, I hate this neighborhood—I'm moving back to the suburbs."

We hired West Philly residents to work on the project, one of whom got the job after cops chased him into our shop for smoking a joint. They had to let him go when they couldn't find the roach. I thought he was good at thinking on his feet. He then spent his first day complaining that he couldn't work because he'd partied like a rock star the night before. I fired him the next day when he was four minutes late.

One West Philly resident that stuck with the program was James B. Jones. He saw me on Market Street early on and told me he'd known of me in the 1980s and would like to paint. The next time I saw him, he had a paper bag full of loose black-book pages, all filled with full-color pieces. He was a self-described bookworm, somebody who drew in books and had never graduated to painting walls. Now, after a couple decades in the wilderness, he was ready to start painting. Hired. The day before we start painting, he tore his Achilles tendon, so I moved him to a position as office manager. The job was pretty easy: draw in his black book all day and talk to people when they came in the shop. One day I watched him suffering for a lack of minutes on his phone, so I sent someone up to Fifty-Second to get him reconnected, and that gave us the idea to paint the *Prepay Is On* wall. James was touched that we mined his misfortune for a diamond in real time, and I was happy to have him take ownership of the wall. The woman who owned the property we painted *Prepay* on called me, upset that it wasn't the right message. So I went to her beautifully maintained house to explain the wall and the larger goals of the project. She pulled out a file of messages that she felt the youth needed to see. One was a Photoshopped montage of Barack Obama in front of the White House and, in the background, a thugged-out youth in a tank top and sagging jeans. A headline blared: "THIS HOUSE HAS A DRESS CODE. PULL YOUR PANTS UP." It was a first to have a property owner suggest a harder image than the one I'd painted. I wasn't the right messenger for her message, so I explained *Love Letter* until she got on board with us. I went back to the shop and told James if he ever needed an idea for something to paint, to go check Miss Parks up on Fifty-Sixth Street.

Back in 1987, when Jane had asked me to join the Philadelphia Anti-Graffiti Network (PAGN), I'd said "No way" because (1) I was PRO-graffiti and (2) I would have been made to do perfunctory work. And even Jane, talented and focused and grown-up as she was, had to paint some pretty boring—and boringly pretty—work from time to time. In the 1980s PAGN painted hundreds of walls, each one more boring than the next. PAGN is now so far removed from the mural business, they painted over my *Daycare Carfare* mural the first time I painted it. The buff man, JR, told me, "I knew you painted it—I thought you did it for some girl." (He got that right.)

There are still PAGN murals all over Philadelphia—the boring walls are like distant relatives cut out of the will of the Mural Arts Program. While painting *Love Letter*, I spotted on Market Street the perfect PAGN mural—a nature scene with no relevance to the neighborhood. Twenty or more years after it was painted, Jane granted us permission to paint over it and, in the same breath, issued the directive that we needed to draw more from the community input we'd received at meetings. When I looked at a list of suggestions, the words "Islam Is Peace" jumped out. I remembered the guy who'd

suggested it at several different meetings. He had gone deeper with the explanation every time: Fifty-Second Street for him was where the Muslim movement had emerged in the 1960s; it had done a lot to break the hold of drugs and gangs on the neighborhood. He was also interested in, and maybe even wary of, the messages we were sending, being savvy enough to understand that even the smallest "We Buy Houses" flyer on a telephone pole says something about the neighborhood at the same time it says something to the neighborhood. So I took his suggestion and had it painted on the wall. As our crew member Darin was painting it, neighbors asked what it was going to say. Upon learning it, they cheered and pumped fists in the air. That was an unprecedented response for us.

I was having trouble explaining to Suroc what we were going to paint on the mural, when a youth walked by wearing the Phillies cap and Sunni beard kit seen throughout Philadelphia: "Yeah, we're gonna paint that guy!" The cherry on top for me, as an artist and ex-graffiti kid, was having the thrill of doing a bit of détournement to that inane PAGN mural, the way the Situationists did to inane comic strips. Jane understandably cringed when I showed her, but I made the point that when we added our new elements, the neighborhood immediately took ownership of this wall that had been merely decoration. What had been ignored is now a source of power for the area. Upon hearing that, she was cool with it: salaam.

The more walls we painted, the more we were able to weave in words from the neighborhood. There were also memories I pulled in from the past, the first being a piece painted by Clyde in 1980 on a roof at Sixty-First Street.

He painted his name in dripping letters that looked like a bomb pop, so in the same location we painted the *Nice Dream* wall and based the look and colors on his piece. I'd run down Clyde some months before at a writer's meeting in Fairmount Park. I knew he'd be there, and he didn't disappoint. I passed him my number and told him to watch the space of his 1980 triumph. When he saw what we painted, he pulled out his phone and called me: "Yo, thank you—that's great! Do you have the picture of the piece I painted?" All I had of his piece was a color Xerox that we'd worked from, that had been soaked in a summer shower and nearly ruined.

But then Johnny Goldstein, man about town, coaxed his friend Mr Blint to come out and meet me at the shop. Mr Blint is a giant of mythic proportions in Philadelphia graffiti. He was not only a prolific painter who built solid networks between Philly and New York, he also photographed every great wall in Philly's golden era from 1979 to '83. In 1983, when he'd had enough of writing and writers, he'd turned away from graffiti and never looked back. Attempts to reach him and bring him back into the fold were made across the intervening decades by his legendary friend Razz and others, but Blint never took the bait. Finally, hearing something was happening on his beloved WFIL rooftop, Blint visited me at the shop at the shop with a photo album under his arm. The photo album contained perfect 35mm shots of the Clyde piece and a hundred more. He filled in a lot of lost memories of West Philly, and in return I reconnected him with some of the memories he had cut himself off from.

I took Blint up on the roof of the WFIL Building at Forty-Fifth and Market. This

**Patrick Griffin**
*ICY Signs*

I had worked for Steve once before, but it wasn't on anything like this or anything this large. He had called about twenty graffiti writers and painters from around the country, and we all set up shop in an old check cashing place. It was like a little graffiti/sign painting camp. At first, it was seemingly well organized—he split people into groups and assigned them addresses and walls for the murals he wanted them to paint. As soon as people were done with their murals and Steve had approved them with a ride-by on the train, he'd have another sketch ready to be painted.

I was there for two weeks and worked on at least nine or ten different murals, maybe more. It got a little crazy toward the end, but it was interesting to learn how Steve worked: he'd make up color schemes as he handed you the new artwork, and I'm pretty sure I painted one mural based on a drawing on a cocktail napkin. He had us running all over West Philly, taking measurements, climbing through backyards and onto roofs with questionable support capabilities. We were just driving these huge articulated lifts down Market Street with bikes in the basket, picking up other people heading back to the shop. It was pretty fun and a little sketchy. We definitely got a few "Why are all these white boys climbing all over these buildings?"

**top:** *Hug Me Like I Hug the Block*. James B. Jones had his cousin in the shop, and she said, "You can't say that—that's what drug dealers say." I said, "Why can't drug dealers be loved?"

**bottom:** The day we painted the fiftieth wall of the Philly Love Letter was the day of the blizzard of 2010. The paint froze to the consistency of gelato. El Josh replaced Rodney Dangerfield as SKREW MSK's hero by painting through the storm until dark. We drove the lift twelve blocks to get this flick, and the cops pulled us over along the way. They were just curious about how crazy we were. Once they understood the lifts were going to be pulled from us the next day (rain, sleet, or snow) and we had to get it done, they let us off with a "Good luck, yo."

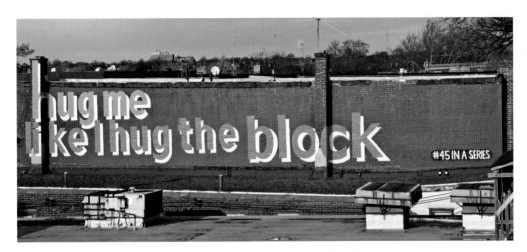

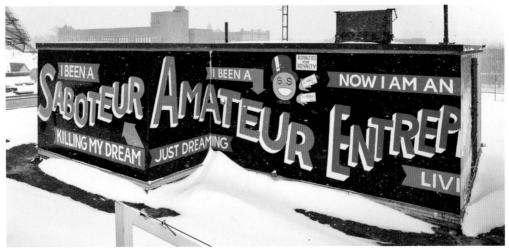

building is the cradle of teen culture in America, where Dick Clark launched *American Bandstand* and where subsequent generations of inner-city youth expressed themselves without Dick's permission. Blint and Razz had painted their names up there in the late 1970s, and all through the '80s I'd stared at their names, which had been permanently preserved thanks to the access ladder to the roof having been removed.

When we started *Love Letter*, getting permission for the WFIL roof was the big prize, and it proved to be an extremely difficult roof to get. The building was owned by a business incubator. In spite of charging us above market rent for our sign shop, the owners would only allow us to paint the building if we painted something that advertised their mission of encouraging entrepreneurship in the neighborhood. It took seven rounds of sketches until I finally I hit the on the combination that opened the lock: "I been a raconteur talking my dream—I been a saboteur killing my dream—I been a amateur just dreaming—now I am an entrepreneur living the dream." They granted me permission, with one condition: we couldn't paint directly on the brick. They instead allowed us to attach aluminum panels to the roof. My take-away from this is that people are so against graffiti that they will accept 275 permanent holes in their wall over a coat of paint that could

be power-washed off in an hour. The only word for this is *bananas*.

Razz told me that being on the WFIL roof felt like being on top of the world, and Mr Blint, reticent about his past on the ground, started talking like he was right back in 1980. Both of them asked, "Put me up," and I did: I painted the classic avatar of Philadelphia graffiti, the smiley face with the top hat, holding two checks made out to these self-made entrepreneurs of style, Razz and Mr Blint. Next to the face, a banner proclaims "Royalties for royalty." I could offer no more, and I could do no less. *Love Letter* is a valentine to a mother and child, a neighborhood and a city, and also, in the heart of its heart, from a grown-up to his childhood. It's the affirmation that the thousands of cans my peers and my heroes emptied were all in the service of love: love of life, love of adventure, and love of graffiti.

Rest in peace, Razz, and sail on, Mr Blint.

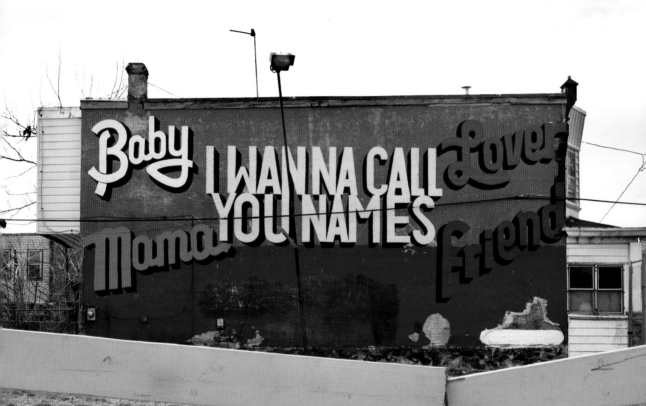

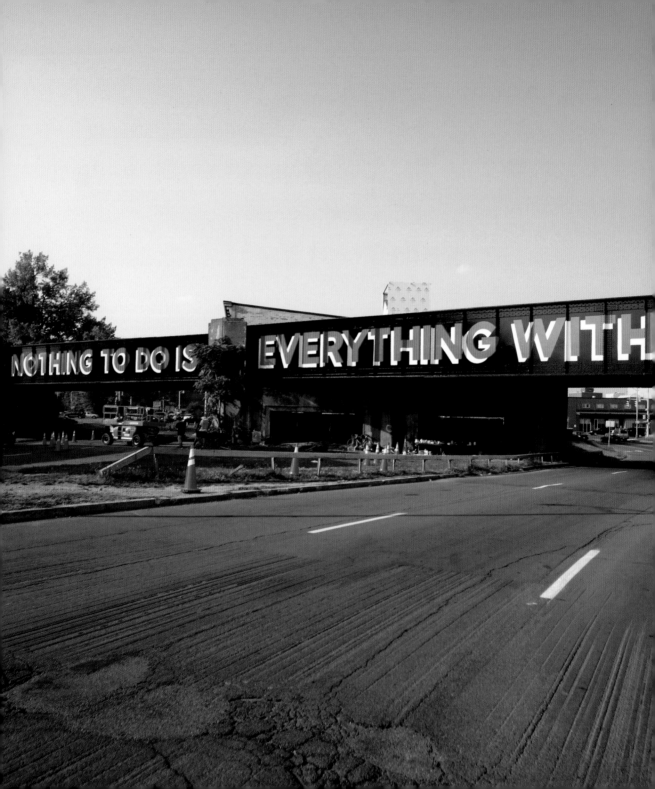

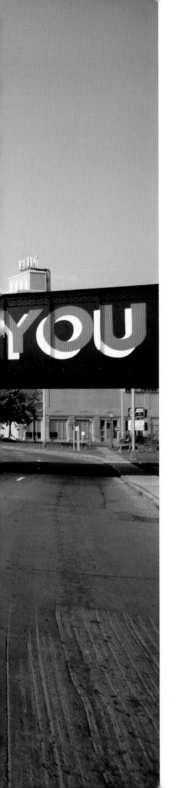

# SYRACUSE

The bridges that cross Fayette and West Streets in Syracuse, New York, were handbuilt in the 1940s from Carnegie steel and the toil of countless people. They were built for a Syracuse of great industry and stand as faithful reminders of the industrial ideals of utility, dependability, and (yes) austerity.

**left:** Dedicated to the local paramedics at Eastern Ambulance of the Near Westside. Their good days are when people are peaceful and they have nothing to do. They never have a good day.

**next spread:** The first coat of paint was the most important. We lovingly primed the bridge with as much care as we gave the topcoat. Reports are it still looks brand new.

77

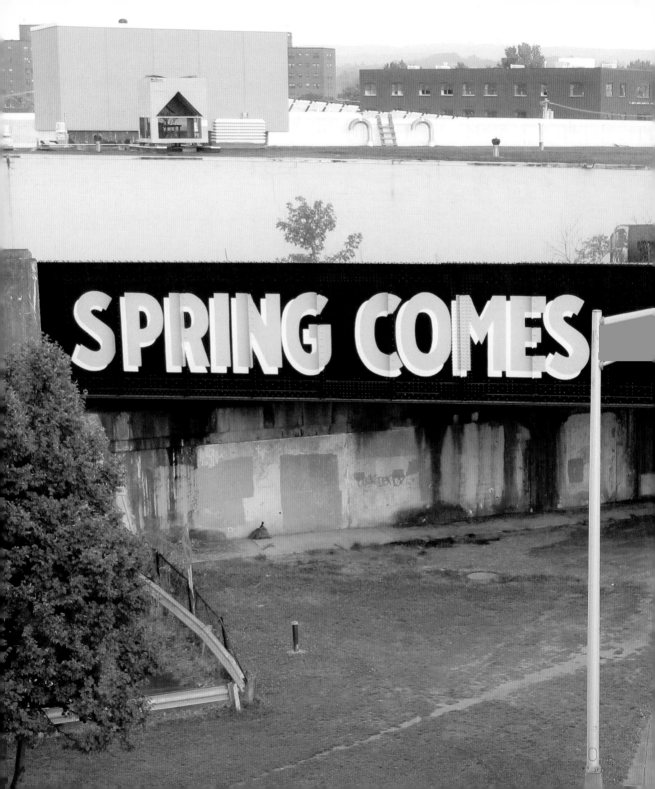

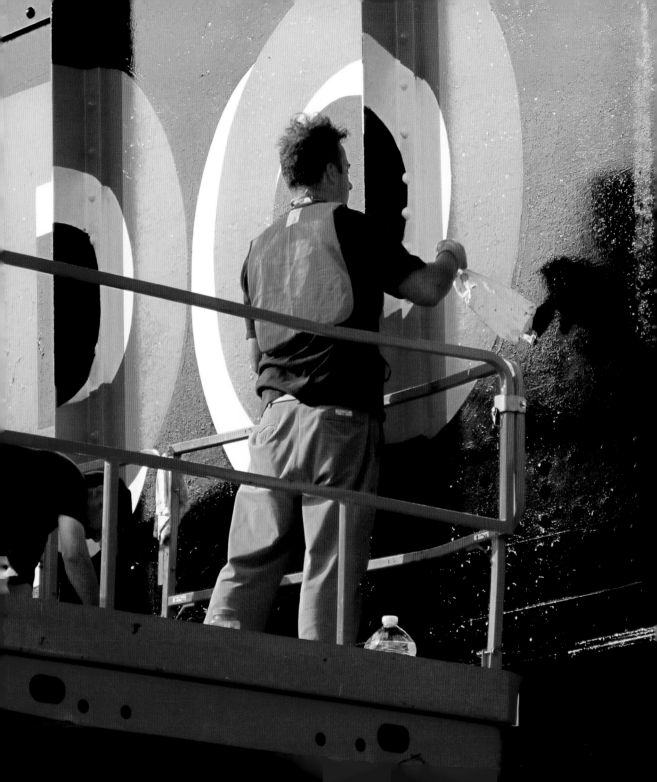

In the era when the bridges were built, sign painting was a viable profession. Like many other professions in Syracuse, it went away because a machine replaced hands, heart, and head. After sign painting as a trade was nearly extinct, it became interesting to me as a medium for art. I learned to paint signs as they had been painted for generations, but I used the letters and colors to talk about love and life instead of commercial concerns. The font I employ was prized by sign painters for its clarity and versatility—qualities that serve me well when I am talking about complex things like love. My use of the sign painters' craft is about the importance of hands, heart, and head being present in my work. The work we were called on to create to renew Syracuse's Westside needed to possess these qualities.

The words we painted were drawn from the neighborhood. The font already had been painted on one side of the West Fayette Street bridge in an ad for local car dealership Romano Ford in the 1960s and again in the '70s. The colors we chose are the federal government's official safety colors, which are used in every industry—a specific blue, red, yellow, green, and, especially, orange. The gloss black had been used to paint the bridge when it was first built. The innovations of the color and the content are layered over that history of the black paint. These painted bridges represent what I believe is the future of Syracuse: taking what has value from the past and remaking it for the future in a way that respects both tradition and innovation.

*A Love Letter to Syracuse* is meant to be from Syracuse to Syracuse. We found, as we were painting, that the love letter is also dedicated to industry: to the trains that pass over the bridges, to the act of painting hot steel in the summer, to collaboration, to polite drivers, and, especially, to improvisation. After painting the two West Street bridges, we realized the design I created for one of the sides of the West Fayette Street bridge would be unreadable from most angles and impossible to paint without blocking off traffic completely. So we had to rework it on the spot. We did what any good signwriter would and worked with the architecture of the bridge to make the words fit with grace and ease. The result is different from our original design, but it serves the words and Syracuse well.

I learned to paint signs as they had been painted for generations, but I used the letters and colors to talk about love and life instead of commercial concerns.

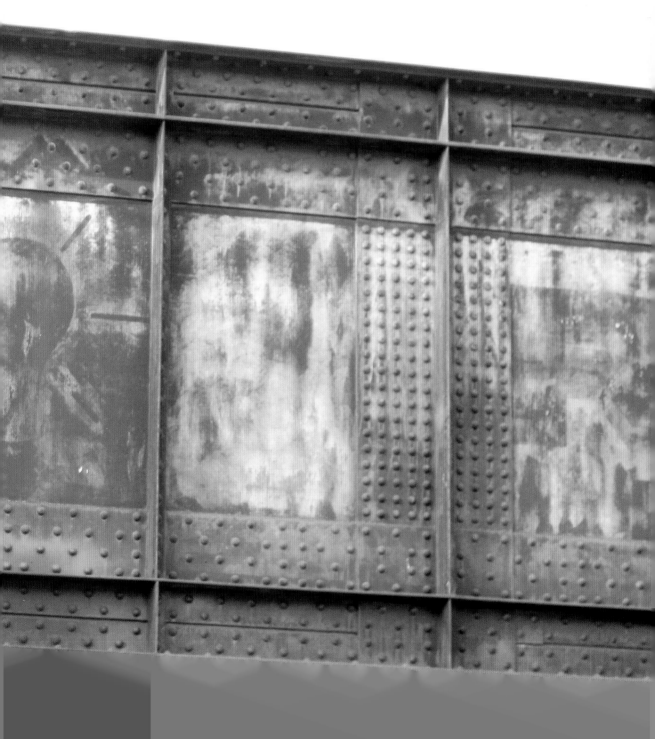

**For 70 years these trestles have been
a visual barrier between downtown
Syracuse and the Near Westside.**

To this end Steve Powers, d/b/a Mark Surface
International proposes to connect the two sides
of the tracks using visual imagery and text with
input by community members gleaned from com-
munity meetings and door-to-door contact. The
project will be painted over a 10-day period in
late August.

Steve Powers wants to know…

*What do you LOVE about Syracuse?*

STORES ARE CLOSE

*What do you HATE about Syracuse?*

PEOPLE DON'T RESPECT
PROPERTY & STEAL TOO MUCH

**Maarten Jacobs**
Director, Near Westside Initiative
The Warehouse/350 West Fayette
Syracuse, NY 13244

*Love A Letter FOR YOU*

---

**For 70 years these trestles have been
a visual barrier between downtown
Syracuse and the Near Westside.**

To this end Steve Powers, d/b/a Mark Surface
International proposes to connect the two sides
of the tracks using visual imagery and text with
input by community members gleaned from com-
munity meetings and door-to-door contact. The
project will be painted over a 10-day period in
late August.

Steve Powers wants to know…

*What do you LOVE about Syracuse?*

LOTS OF PEOPLE INSIDE
LEAVE KEYS FOR QUADS

*What do you HATE about Syracuse?*

THROWIN TRASH OUT
THE WINDOW.

**Maarten Jacobs**
Director, Near Westside Initiative
The Warehouse/350 West Fayette
Syracuse, NY 13244

*Love A Letter FOR YOU*

We have at least ten cards that say "NOTHING" for both questions. That, in addition to what the paramedics told us, inspired the *Nothing To Do* bridge.

**For 70 years these trestles have been a visual barrier between downtown Syracuse and the Near Westside.**

To this end Steve Powers, d/b/a Mark Surface International proposes to connect the two sides of the tracks using visual imagery and text with input by community members gleaned from community meetings and door-to-door contact. The project will be painted over a 10-day period in late August.

Steve Powers wants to know...

*What do you LOVE about Syracuse?*

DIVERSITY. GOOD PEOPLE
THINGS TO DO

*What do you HATE about Syracuse?*

RACIAL DIVIDE

Maarten Jacobs
Director, Near Westside Initiative
The Warehouse/350 West Fayette
Syracuse, NY 13244

*Love A Letter FOR YOU*

WATCH OUT FOR EACH OTHER

**For 70 years these trestles have been a visual barrier between downtown Syracuse and the Near Westside.**

To this end Steve Powers, d/b/a Mark Surface International proposes to connect the two sides of the tracks using visual imagery and text with input by community members gleaned from community meetings and door-to-door contact. The project will be painted over a 10-day period in late August.

Steve Powers wants to know...

*What do you LOVE about Syracuse?*

I LIVED HERE
FOREVER.

*What do you HATE about Syracuse?*

NOTHING
-YOUNG KIDS W/ ~~DRUGS~~ GUNS

Maarten Jacobs
Director, Near Westside Initiative
The Warehouse/350 West Fayette
Syracuse, NY 13244

*Love A Letter FOR YOU*

I PAID THE
JUST TO SE

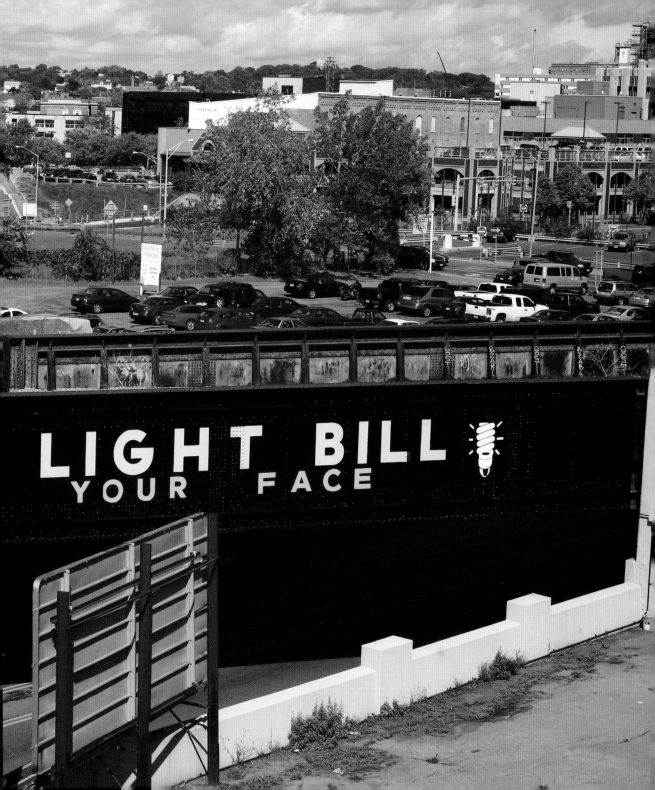

**Isaac Rothwell**
*Arts promoter, StudioDOG Productions owner, and Westside resident*

I had always thought those bridges should be ambassadors for the n'hood, and I'd had conversations with others about the possibility of something becoming of them like this. Initially, I had envisioned the end work having more imagery and not being as text-heavy. Watching the text being painted was kind of like watching *Wheel of Fortune* and trying to decipher what the final words and message would reveal.

Steve had an aura that made me believe from the start he would represent my neighborhood's values and outlook in his work. I remember having a couple of group meetings with Steve and then seeing this dude with the flattop in the park, chilling and kicking it with n'hood kids. I could tell he understood us in the Westside and was good at getting inspiration from us.

For the most part, the project has become part of the fabric of the area. People are using the bridges in local music videos. For me, it's an everyday reminder of what it means to love being here. Haters are always going to hate, but it takes special people to spread love the Brooklyn way and, in this case, the Syracuse Westside way.

left: Being interviewed by Carole Horan for her monthly column in a Near Westside newsletter

This jobsite went zero days without any workplace accidents.

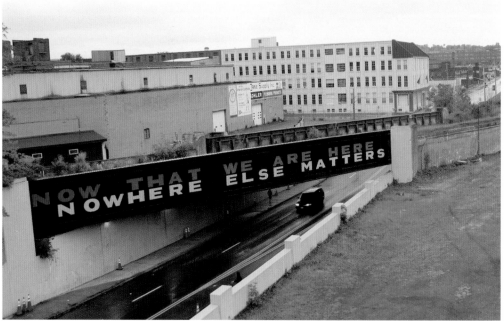

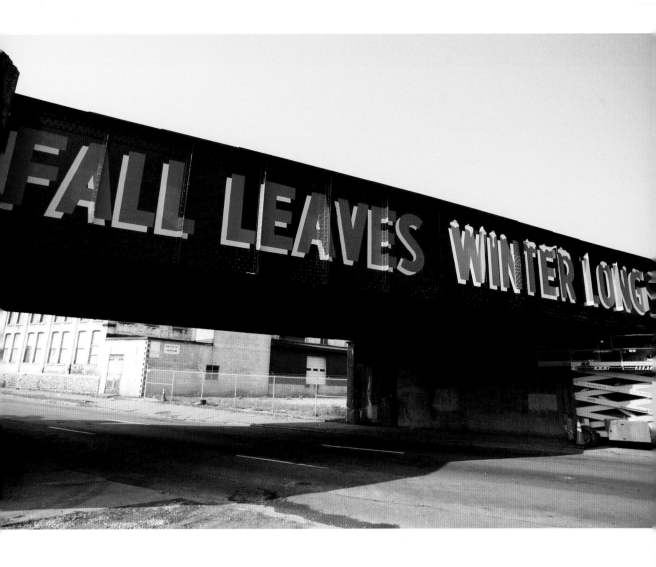

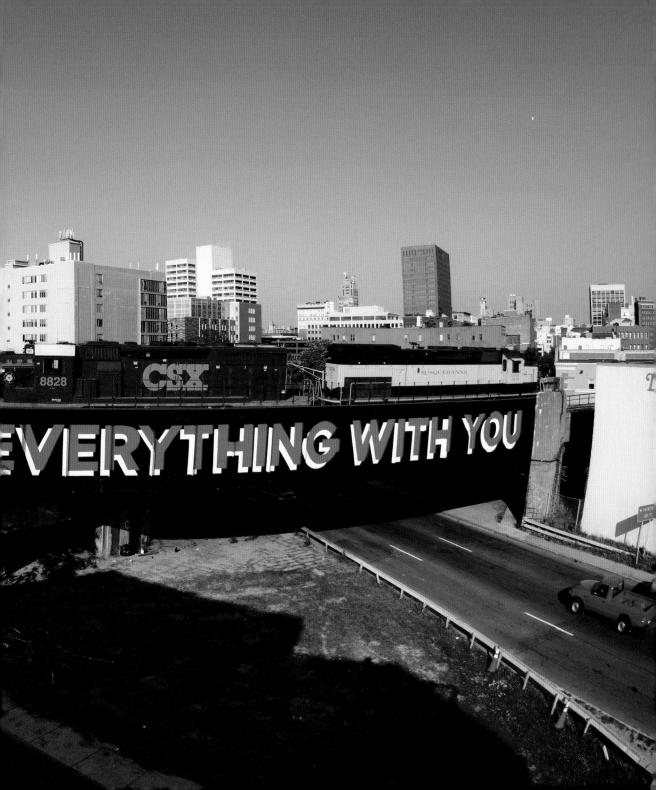

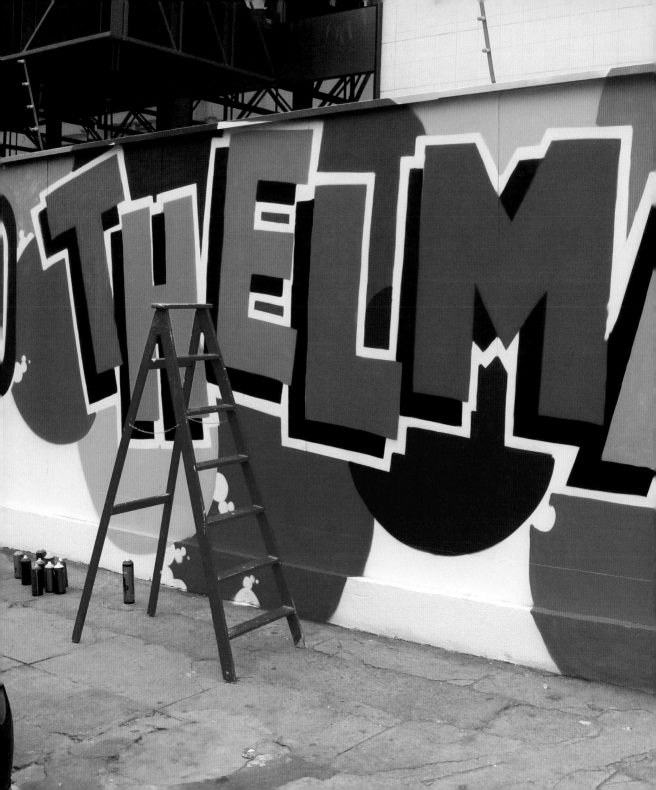

# SÃO PAULO

There's a team of twin brothers—Otávio and Gustavo Pandolfo—from the Centro district of São Paulo, Brazil, who call themselves Os Gemeos (the twins). For the last twenty-five years they have been traveling all around their city, painting characters based on the people who live in the different neighborhoods. They do it in a very cheerful, pretty way, but at the same time their work has real social content, reflecting the people in these communities and the conditions they endure. They are also masters of Pixação, a hand style of graffiti writing that is cousin to the Philadephia hand style. We'd been waiting a long time to visit our relatives, and we got two opportunities, three months apart.

Andy PURE TFP Dolan was in charge of color selection and background painting. Nice, right?

In 2010 SESC (Social Service of Commerce), an arts organization that has worked with Os Gemeos, saw the *Love Letter* project and asked us to write a *Love Letter* to São Paulo. This group is funded through taxes on businesses, and they place art and cultural programs throughout Brazil. Since they emailed me with scant details, only a few weeks before the project was slated to start, I felt like I was dealing with a bunch of ravers instead of a legitimate organization. When I arrived, I quickly found out I was dealing with the best arts organization in Brazil. Os Gemeos had nothing but praise for them and told us we were lucky to get the call.

We were tasked with painting in a neighborhood called Bom Retiro, which means "good place to retire." At one time, it had been a good place, where coffee barons built their mansions, a spectacular suburb within the city. It was also the center of immigration, where generations of successful immigrants had settled and flourished before moving on to the next rung of the ladder. But crack had arrived in São Paulo a mere five years previously, and Bom Retiro, where the cops had corralled all the drug activity, was filled with hundreds of addicts in rugby scrums on every block. It looked like Michael Jackson's "Thriller" video, set in the South Bronx in 1985. Bom Retiro was known as "Cracolandia," and if people weren't smoking or selling crack, they were dragging trash to get money. But in a very São Paulo way, right across the train tracks from this carnage was a very prosperous neighborhood, lined with clothing shops on well-swept sidewalks. So I was faced with diverse populations of people who existed near each other and didn't acknowledge each other, and I was trying to create a messaging system to reach the widest cross section of these populations. In Portuguese. In five days.

When I'd been in São Paulo a few months prior, I'd picked up the Portuguese phrase "*Volto já,*" which means "I'll be back," so we called this project *Volto Já.* That suited SESC's needs very well, as it wanted the neighborhood to come back. I asked the people who hired us, "Is there a community here?" "Oh no, nobody lives around here." But after five minutes of walking around, we found, in fact, that there were hundreds of people who lived around there. A gregarious photographer and fixer named Flavio Samelo was helping us and seized the task of collecting people's names and interests. He would flip out when he got a name that was especially Brazilian because it mashed up two names to create a new one, like "Josevaldo."

Even in Flavio's smiling, charming presence, people were naturally suspicious, but once they saw what we were doing, we received an avalanche of requests. We spoke to a woman named Alexandria who was really into PlayStation. I took Dercio's name—he was one of the guys hauling carts of paper—and we painted it. We painted a cartoon of the owner of a pizza chain named Habib's dressed like one of the cops who patrol Cracolandia and don't really do anything. When the gate of the building we were painting opens in the morning, it swings over the painting of Habib, as if he is in jail. We painted the name and face of a parking lot attendant named Ismael. I painted the legs and crisp white socks of Sorte, who was dragging trash back and forth. We painted the names of business owners and crack addicts—everybody was rendered equal in enamel.

Os Gemeos and Brazil have had a huge impact on the look of graffiti in the last fifteen

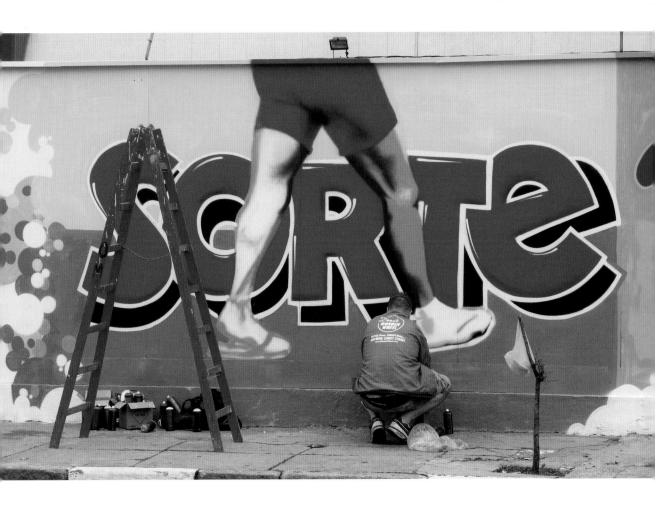

Sketching out *Sorte* (lucky) and our lady with the clean socks.

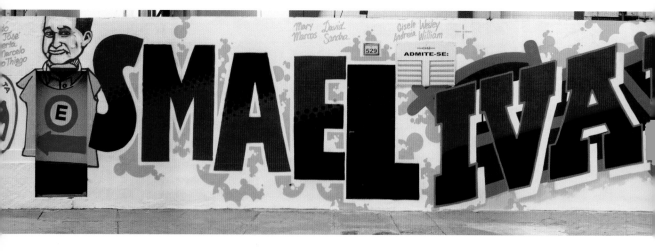

years, so I brought something to São Paulo from Philadelphia. In 1986 Suroc had started painting a graphic, pop style of graffiti that came right off of candy wrappers. We applied that style to the walls of Bom Retiro, using all the really well-designed packaging from the snacks and treats that are available in São Paulo. The *Volto Já* lettering is from a popular candy called Amor, which is like a Reese's Peanut Butter Cup without the chocolate. Using the candy wrappers was an effective engagement strategy. People were familiar with the logos, many of them part of São Paulo's cultural DNA. It allowed us to paint work that was inherently Brazilian without copping a pose and to connect on a real, fundamental level.

This is graffiti! And it could be beating a community over the head. But it's doing the opposite: it's empowering a community, using names, color, design, and spray paint. Graffiti is putting a name on something that doesn't belong to you. But when you put the names of the community on something, then it belongs to everybody. Os Gemeos do it every time they paint a figure on a wall; it stands for all and it claims the wall for all. The wall we painted in Bom Retiro hadn't been doing anything for anyone, and we turned it into something totemic that the whole neighborhood could rally around.

In the end, Os Gemeos paid us the compliment of hanging out. And we got to hire their great associate to help us—Finok, from the VLOK crew, who brought along Toes free of charge. That was like hiring Picasso and getting Matisse thrown in as a bonus. It wouldn't do. We paid them both the same rate we were getting, which was generous by New York standards, never mind São Paulo. In return they took us writing in the streets on Sunday, and we had the best day of our painting lives. Someday we'll bring all of the VLOK crew back to Philadelphia and have a proper family reunion. I hope they bring a backpack full of Amor.

A LOVE LETTER TO THE CITY

A LOVE LETTER TO THE CITY

A LOVE LETTER TO THE CITY

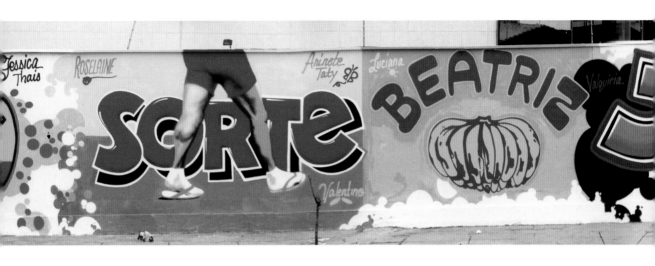

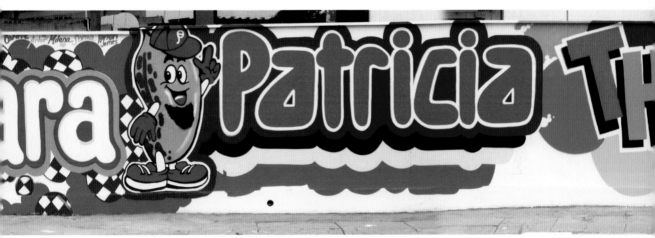

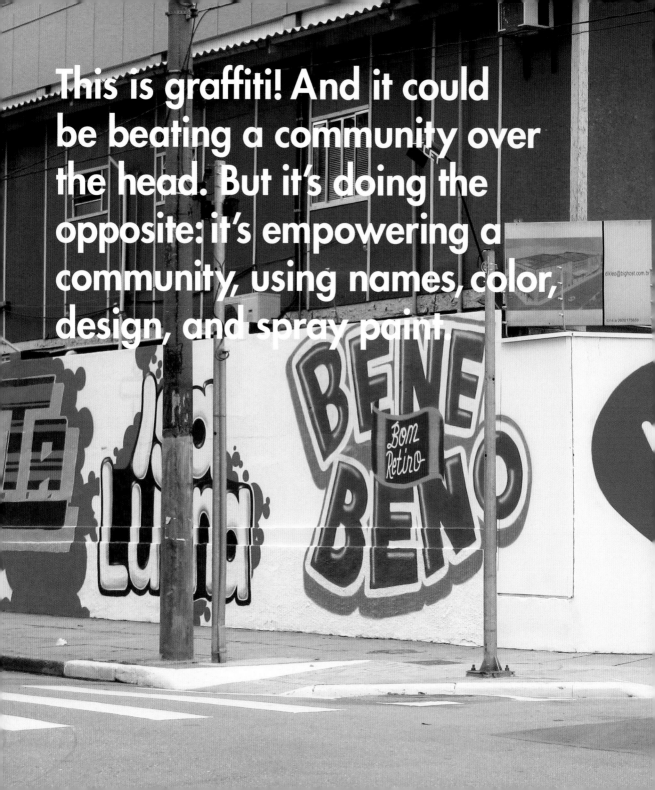

This is graffiti! And it could be beating a community over the head. But it's doing the opposite: it's empowering a community, using names, color, design, and spray paint.

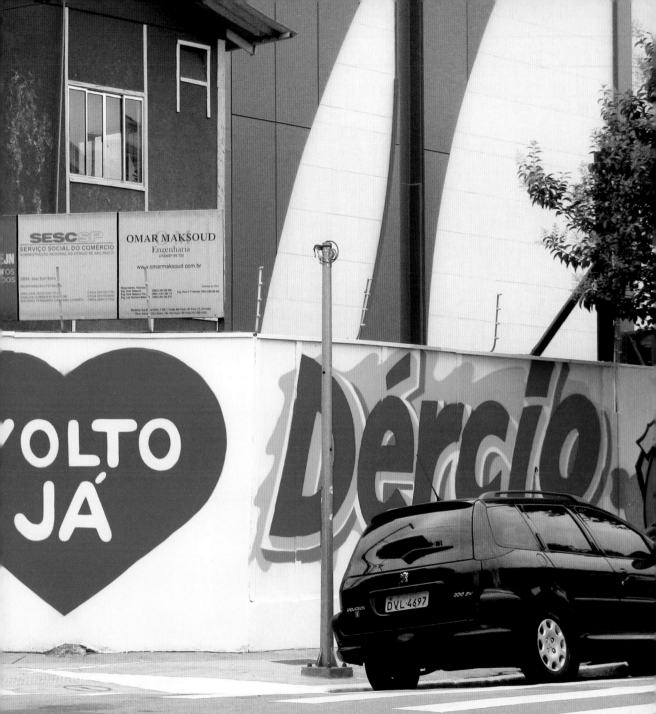

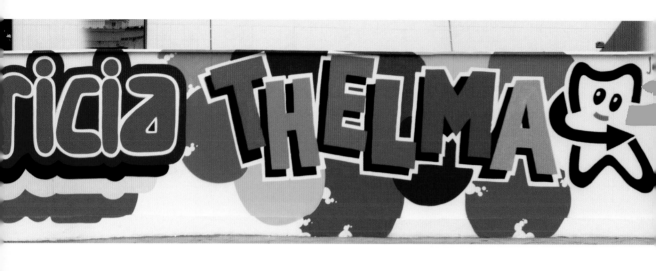

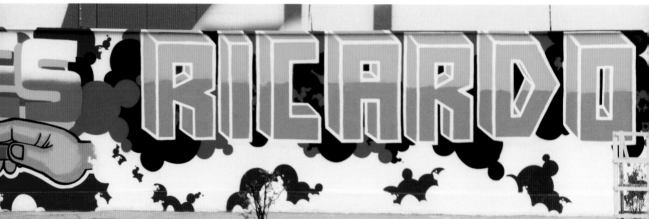

A LOVE LETTER TO THE CITY

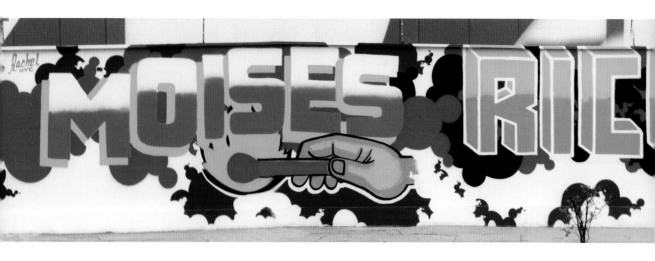

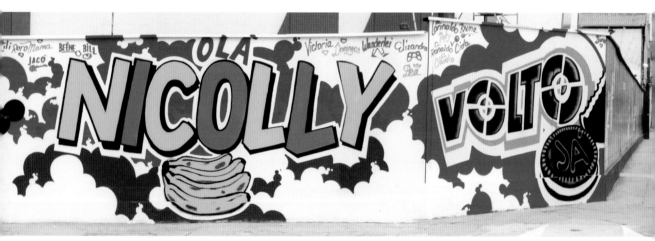

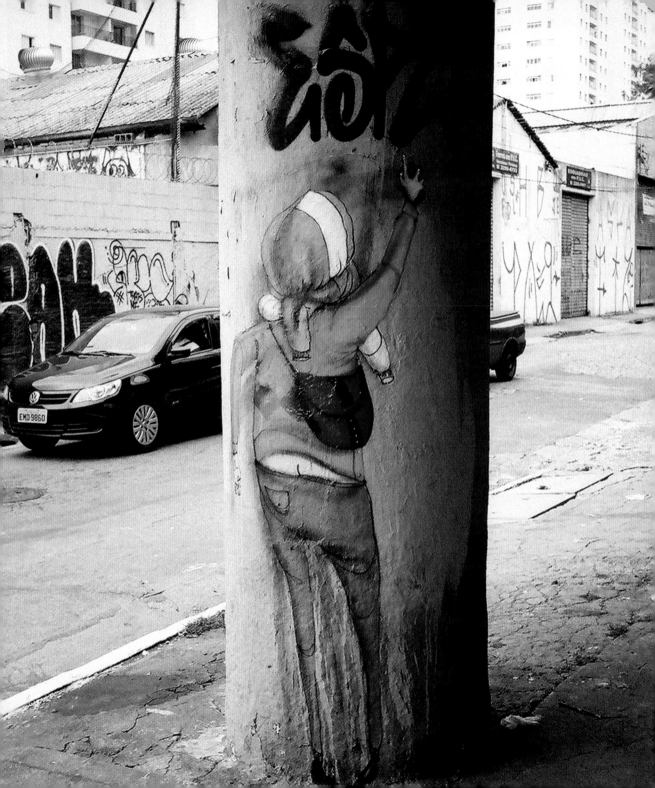

**above and right:** Wrappers that inspired our work in Bom Retiro

**opposite:** It's always useful to have someone else posing in front of your graffiti. Thanks, Nicolly!

A LOVE LETTER TO THE CITY

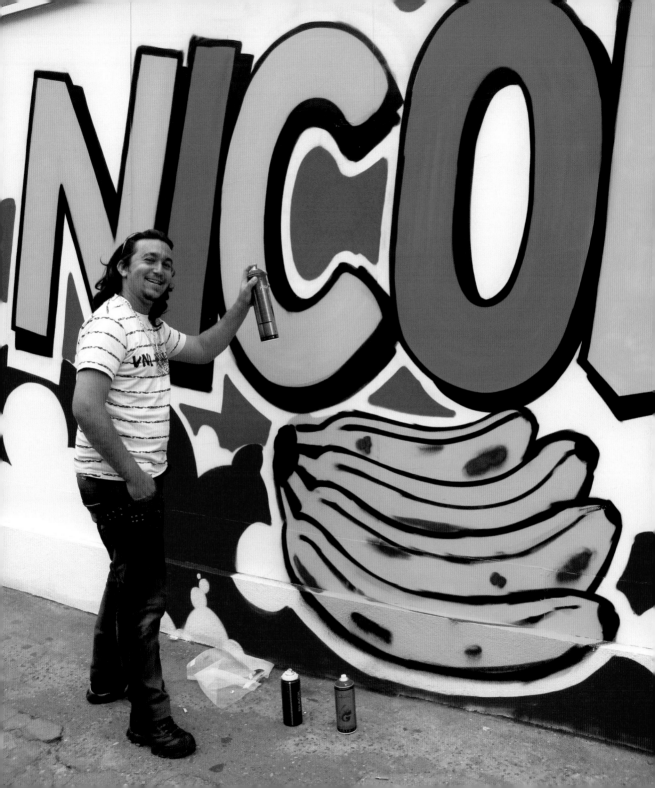

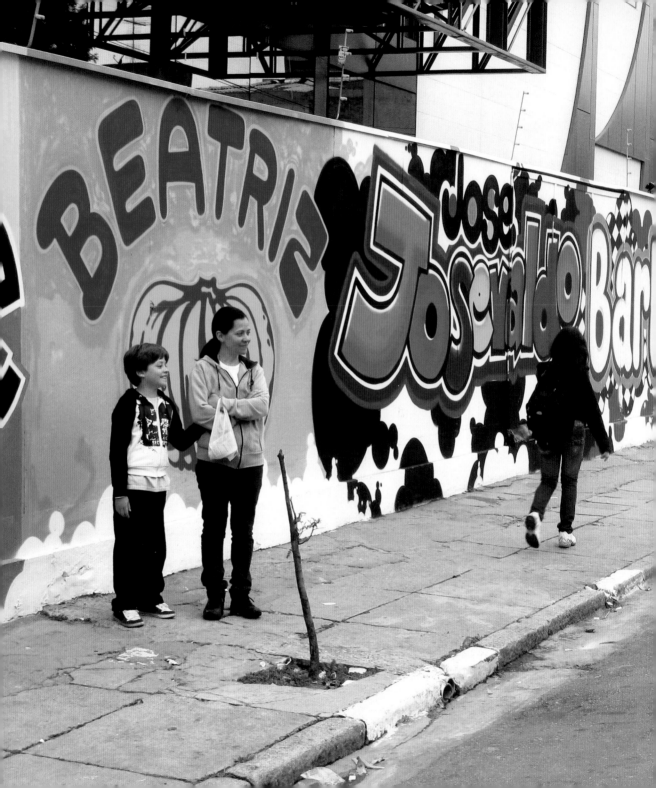

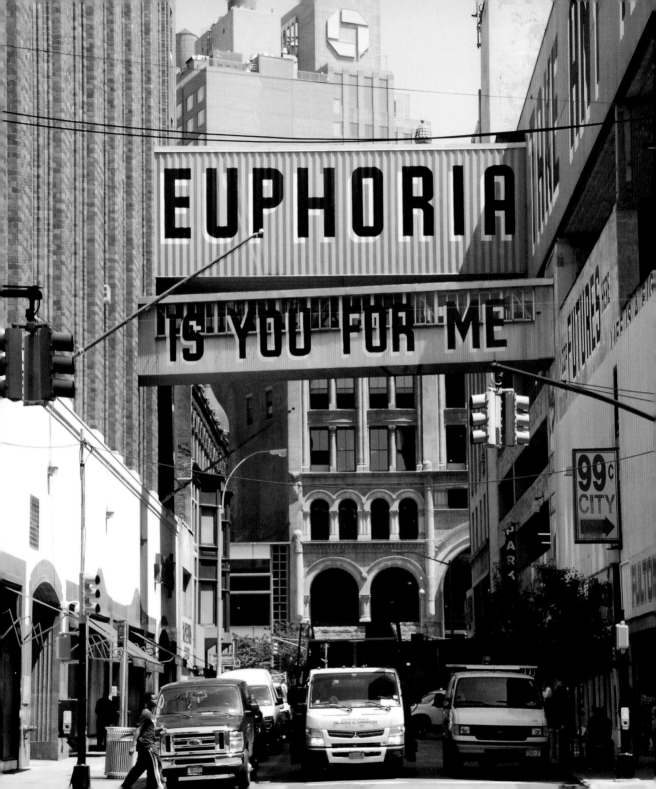

# BROOKLYN

I get calls from people wanting to write a *Love Letter* to their city, asking me where to begin. I tell them, "The first thing you'll need to do is find a guy like Joe Chan." Joe Chan was the president of the Downtown Brooklyn Partnership, a nonprofit development corporation. He approached me with the idea of *Love Letter Brooklyn* and had a budget and permission to make it happen on several buildings in and around Fulton Mall. Great—slam dunk, let's get started. Oh, wait—not so fast.

This is for you, whoever you are.

115

Now the borough president wants to open this up to a competition, and thirty-four people submit proposals. We make our pitch and find that ours has tied for first with another proposal, so the budget gets split between us. OK, no problem—we'll handle it. Oh, wait—the parking garage we were going to paint is no longer available, and the funds aren't going to be allocated for this project. Hold on. I'm holding. OK, Macy's has offered their garage and is now putting up the budget.

Now, imagine all of this taking place not over the course of one rambling paragraph, but over eleven months. But while I was in a holding pattern, Joe Chan handled every problem, reversed every reversal, and taught a master class in tenacity. I didn't see any of the grinding politics—Joe just dealt and dealt and looped me in from time to time.

Finally, a year after I was first contacted, Macy's held a press conference announcing *Love Letter Brooklyn* on the Fulton Mall. Marty Markowitz, the Brooklyn borough president, made a speech and handed out "Brooklyn" lapel pins. I said a few words and introduced the one-man community who supplied the words for *LLBK*, Dave Villorente.

Dave Villorente, the Brooklyn Story Repository, is a native of the borough and a towering figure in New York graffiti. I profiled him in my book *The Art of Getting Over,* where he provided two crucial elements. The first, his amazing snapshots of other writers, deftly illustrated that the writers had as much style as their painted trains. He also came through with a vivid first-person account of growing up in Brooklyn in the 1980s and '90s. While most other graffiti writers' memories were malleable, Dave's were diamonds, tough and polished to

high clarity. After talking to hundreds of people in Philadelphia and Syracuse, I trusted a single person to speak for the many thousands of people who now call Downtown Brooklyn home. Dave Villorente delivered like I'd left the basket unguarded.

Numerous new condominium developments have sprung up in Downtown Brooklyn in the last decade. We were generously donated a ground-floor space in one such development, a building of a couple hundred units that sold out before ground was broken. The fact that we had a rent-free space for more than a year testifies to a lag between the willingness of people to live in the area and the willingness of businesses to lease there. The Downtown Brooklyn Partnership was working to close that gap in a hundred seen and unseen ways. One very visible way was to change the look and feel of the Fulton Mall. For Dave and generations of Brooklynites, Fulton Mall was an affordable place to get clothed, fed, and entertained. It is an eight-block strip mall with large sidewalks and a street reserved for buses and emergency vehicles only. In the decades when Dave hung out at the mall, it was dominated by clothing and sneaker stores, record stores, beeper/cell phone shops, wig shops, and gold stores. It is hugely profitable, the third-largest commercial center in New York City. But with the influx of development, rents have been rising, and landlords have been looking for new tenants. The Downtown Brooklyn Partnership successfully upgraded the mall to attract national chain stores that hadn't bothered with Fulton Street since the 1950s. Once that plan was realized, they looked for a public art project that would bring people back to the mall. I was interested, but I was also interested in representing the

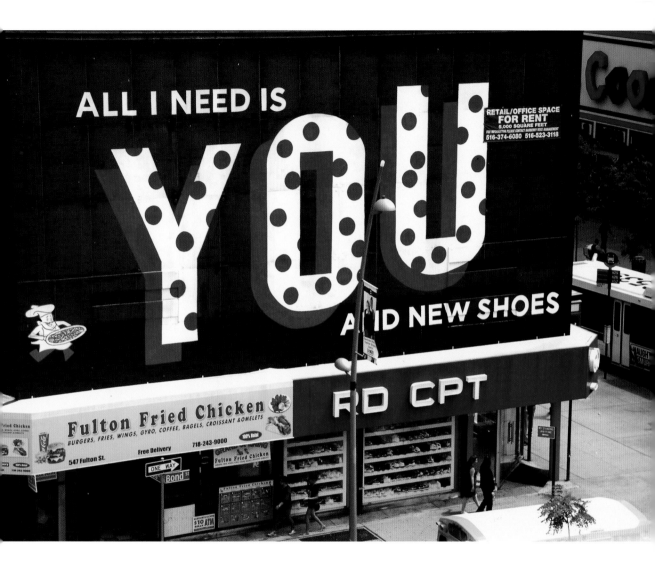

The red dots in "YOU" are pepperoni. Tony of Tony's Pizza (gone, a victim of the 99¢ pizza trend—now it's Fulton Fried Chicken) disputed this and said they were "polka dots." So we added the pizza chef.

BROOKLYN

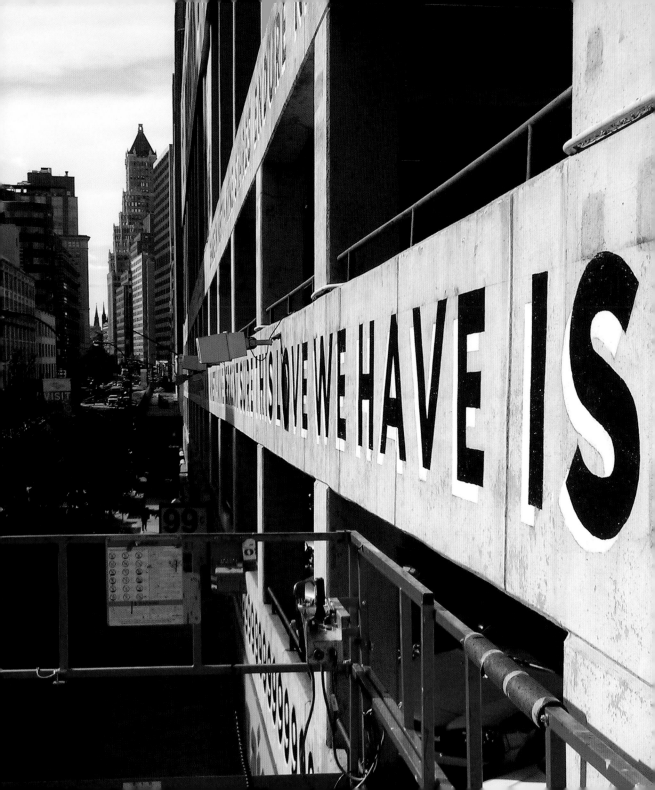

The following text is handwritten over the photographs:

BORN IN BRICKS HOME COULD BE A SAFE
RAISED ON ROCKS

YOU TAKE ANY TRAIN

I WAS SUTURED HERE

I WAS NURTURED HERE

FULTON CLOSEOUT

BREAKFAST LUN

MEET ME DOWNTOWN FOR A FEW

FROM NINETY NINE TO NINETY NINE AND FROM NINE TO NINE AGAIN WE STARE NINETY NINE STARES

I AM NINETY NINE PERCENT SURE YOU ARE NINETY NINE PERCENT PURE AND NINETY NINE POINT NINE PERCENT SURE

99 FULTON CLOSEOUT CENTER 99.9

WE WILL LET STREET STREETS

HUNGR ER PA

I GREW UP IN YOUR ARMS RAISED ON FEET AT A GREW UP IN YOUR ARMS

WITH NO TRAIN OF MY OWN BUT SHOES AND RAISED ONE FLOOR AT A TIME

WAITING IS OK IF YOUR COMING

EVERY STREET CARRYES US SCRAPES Cla Cloud

**opposite:** Livingston Street. The tallest building in the background is Abraham J. Simberg's Brooklyn Chamber of Commerce Building. It won landmark status as we were painting our landmark.

**above:** Sketchy, at best

**next page:** Le Josh is focused. You can see how booming Sean Barton's "WE MAKE SIGNS" window splash on the ICY Signs storefront is in the background. Building management asked us to remove it within days.

When I go into a community, I try to find visual cues that are already there and introduce them into the work.

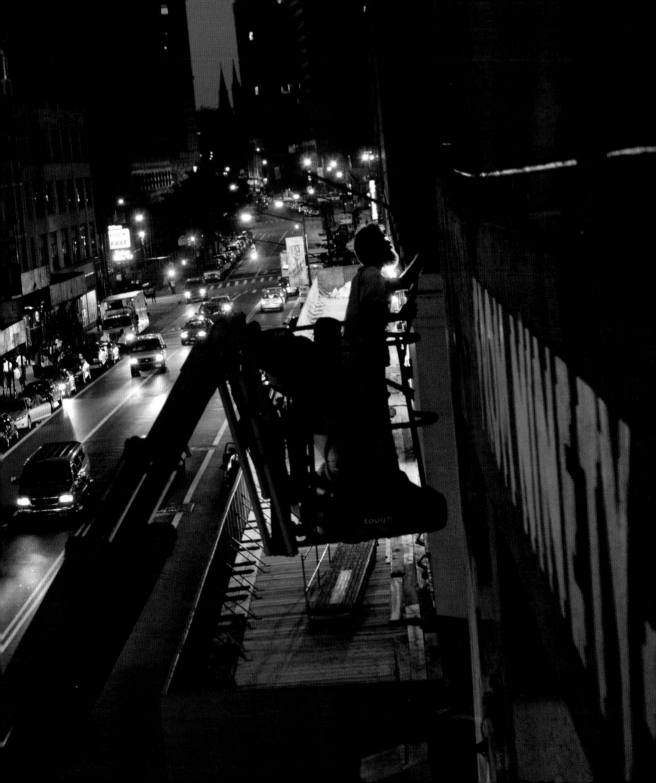

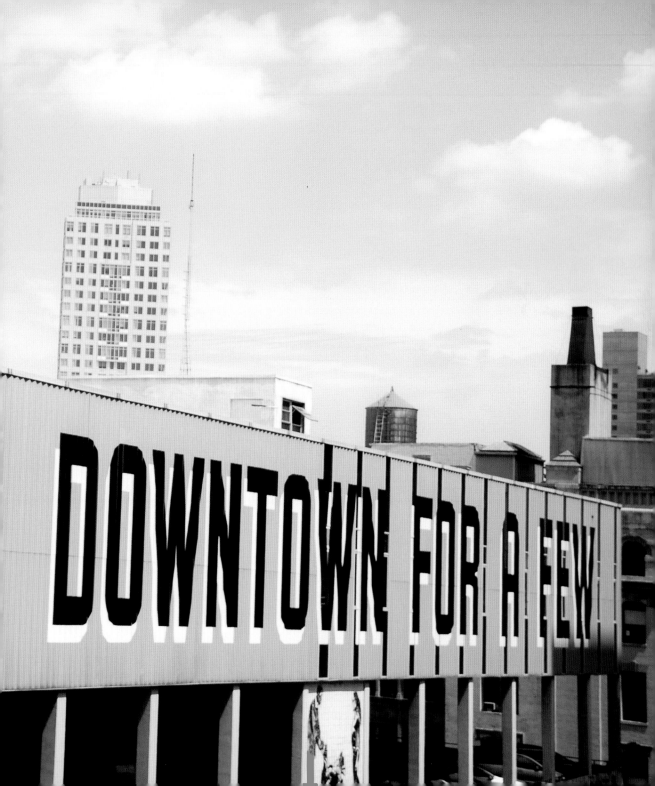

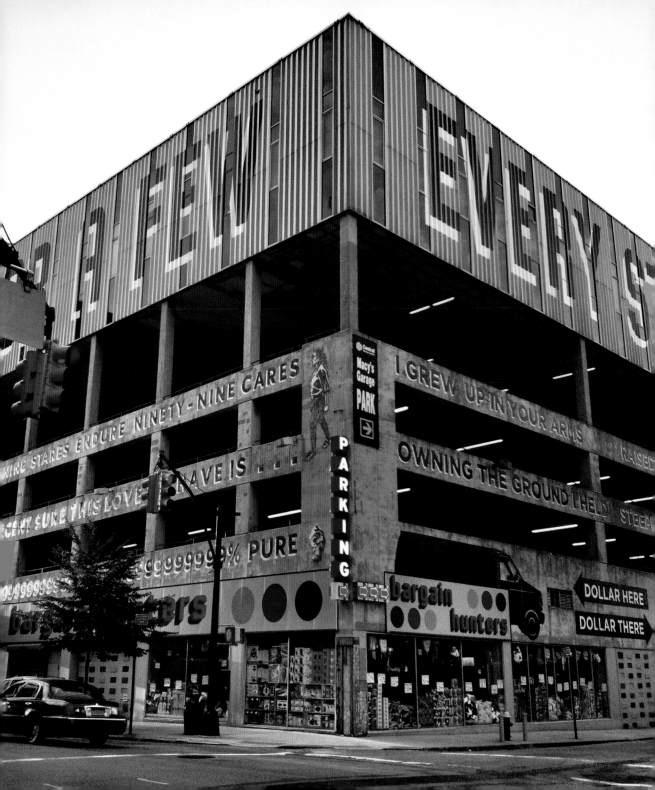

Brooklyn that was here first, or, at least, had been here last.

Dave and I sat at Junior's restaurant, under the watchful gaze of Biggie and Diddy, and he ran down what Downtown Brooklyn meant to him. He actually lived in Fort Greene, but Downtown Brooklyn was his gateway to the city and home again. Every train in the transit system has a stop in downtown, and once he got there, he could get food and walk home at any hour of the night, any day of the year. He has pictures of himself as a kid with the Easter Bunny and Santa at Macy's (then Abraham & Straus), and he remembers the day the Albee Square Mall opened. Albee Square Mall was adjacent to Fulton, and the day it opened, a roller skating monkey named Zip performed for the crowd. Dave would tell me story after story like that, funny and strange and sometimes frightening, each of them bringing a bygone era of Brooklyn into sharp focus. After a hundred stories, I had enough material to cover the eight-story monstrosity that is the Macy's garage, and I then had only the logistical issues of painting to deal with. After the year we'd had so far, it was a piece of Junior's cheesecake.

Thinking back on the actual painting of the building is enough to work me up into an anxiety attack. The traffic alone is crazy; Livingston Street has welfare offices, disability offices, and methadone clinics that keep the street and the surrounding blocks packed with people all day long. We couldn't pull out the lifts until after 8 p.m., when the crowds have cleared the area and the 99-cent stores have shut their gates. Even after eight, our flagmen had to boss up on the traffic and dollar vans that would drive around the lifts and create potential accidents at any given second.

We'd rented lifts before, but every time, there's a learning curve on the equipment. If you're lucky, you'll get a run-through of the controls from the guy dropping off the lift. We're hardly ever lucky. The bigger the lift, the more complicated it gets. If you extend the lift the wrong way or position it in a way that's off-balance, the lift has a safety feature that freezes the machine in place and blares an alarm at you, demanding you figure out your mistake. Until you do, you're stuck wherever you are. I know it's not just me—I see workers all the time stuck on lifts, trying every combination of switches and controls until the lift decides they are on track again and starts moving. Lew Blum said it best: "The smart thing would be to have a voice calmly saying, 'Hey, you don't want to do that.' Instead, it's screaming 'FAILURE' over and over." I only had to have "FAILURE" screamed at me a hundred times before I got the hang of handling a lift.

Even a thorough knowledge of your lift and traffic-free streets aren't enough—you'd

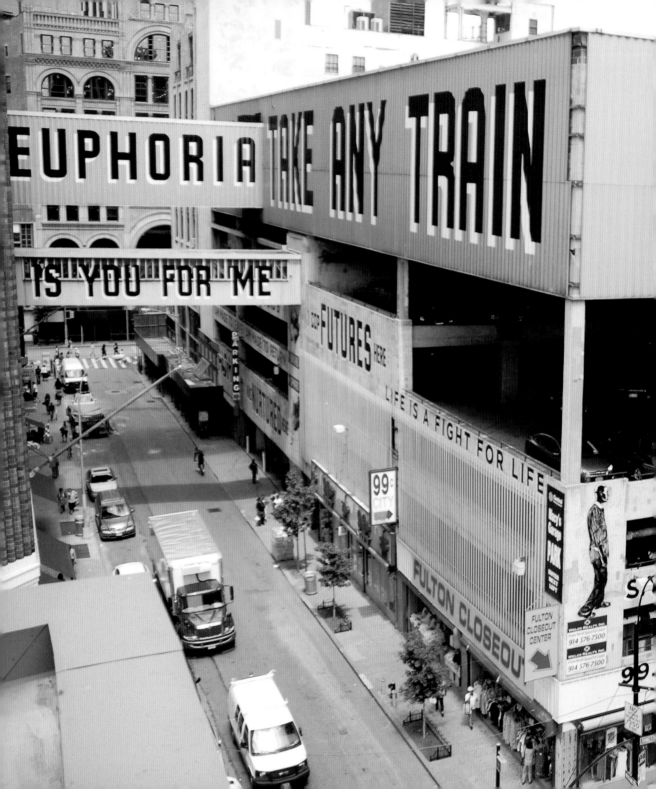

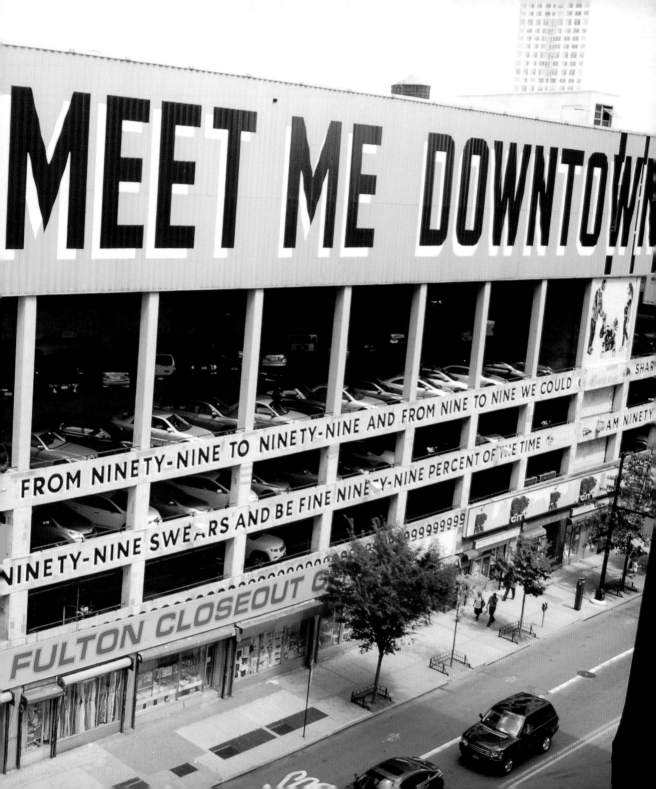

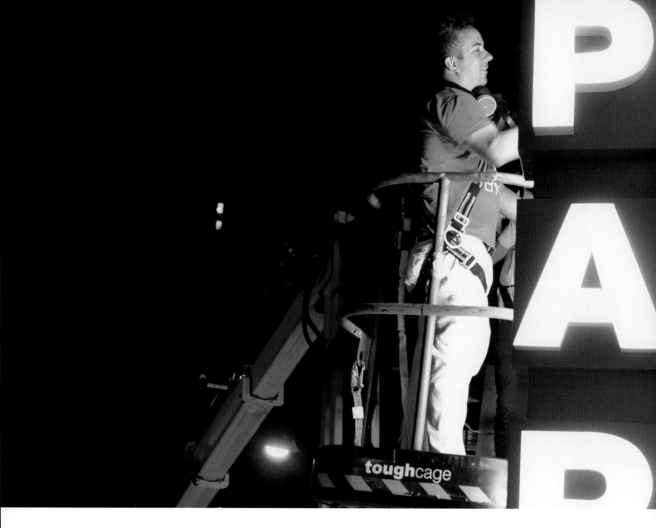

**above:** On the forty-five-foot lift. I can tell this was before the basket got smashed in (it happens), because two people still fit in the basket.

**next spread:** Dollar vans are only 99 cents at Bargain Hunters.

A LOVE LETTER TO THE CITY

better be ready for anything. We were told that we couldn't store the lifts on the sidewalk, so we arranged for parking nearby. I managed to secure a space for one of the lifts inside Macy's loading dock, and the first day I pulled it out, I got it halfway into the street when every light on the control panel turned red. I knew this wasn't operator error, and as I was going through the manual, a parking lot attendant mentioned there'd been an accident. When I pressed him, he told me that a guy driving an Access-A-Ride van (essentially a Ford 350 step van fitted out with a wheelchair lift) had keeled over with a stroke and had put the gas pedal to the floor, crashing into the gate in front of the lift as fast as he could get the van going in fifty yards. The lift-rental company sent an engineer, who took one look at the lift and saw impact damage I hadn't even noticed: "Holy crap, look—these bolts are sheared off, and the power cords got ripped out!" If I had gotten it in the air, it probably would've collapsed onto Livingston Street. Just another day at the office.

I had at various times thought about using a variety of colors and fonts on the wall, but in the end decided I wanted it to look like a newspaper, with a headline font and a copy font. The headline font I found on the inside of the building, on a lit-up directional sign. Justin Green, a signwriter with thirty-five years in the game, told me it is called Gaspipe and is prized by beginning signwriters because you don't need a trained eye, just a ruler, to get it right. When we scaled it up from eight inches to sixteen feet, it looked like something painted on a gantry on the Brooklyn waterfront, so it settled into the landscape perfectly. The copy font was Gotham, designed by Tobias Frere-Jones in 2000 and based on a style of lettering that American signwriters have used since the 1930s. Whenever I could, I choked up on the E's, F's, R's, and P's that Gotham stretched out, to make it look more like signwriters' Gothic lettering.

With two colors and two fonts, I had everything I needed to tell Dave's story. But beyond Dave's story, I wanted to write some romantic pickup lines for Brooklyn to have and to hold. And I needed to have a Brooklyn couple to wrap those lines around. Fortunately, Livingroom Johnson, his wife Katiya, and their beautiful baby crossed my path on Schermerhorn one day. Livingroom is an interesting guy, an author and a raconteur who is a little myth and a lot of shoe game. Where fact and fiction begin and end with him is hard to figure and, since he's a writer, totally beside the point. So I cast him and his wife as Mr. and Ms. Brooklyn, an unlikely pair that Brooklyn has made inevitable. They walk toward each other from opposite ends of the garage on Livingston and meet in the middle, where a stroller has appeared in front of Livingroom. (That's how it happens in real life, too!) Above them unfurl the words "Meet me downtown for a few," and below them is a block-long poem featuring the words "ninety-nine" over and over again, in tribute to the three 99-cent stores that run the length of the block. I rendered the figures in black and white Rust-Oleum spray paint with stock caps, consistent to my work going back to the 1980s. Black and white also represent night and day; the black and white cookie; film noir; and, of course, the newspaper. They not only hold gravitas, they are the color palette of speed and illegal deeds. Five months after we painted the garage, black and white were chosen as the colors of the Brooklyn Nets, which is only right, since people think the "ninety-nine"

poem is about Mr. "99 Problems" himself, Jay
Z. It's not, but the thought has crossed my mind
about ninety-nine times.

In its entirety, the building reads:

YOU TAKE ANY TRAIN
MEET ME DOWNTOWN FOR A FEW
EVERY STREET CARRIES US HOME

BORN BUSY AS A BROOKLYN BOUND B
I AM MADE TO LEAVE
I AM MADE TO RETURN
HOME

ONWARD UPWARD

I WAS NURTURED HERE
I COP FUTURES HERE

LIFE IS A FIGHT FOR LIFE
AIDAN SEEGER IS HERE

FROM NINETY-NINE TO NINETY-NINE
AND FROM NINE TO NINE
WE COULD SHARE NINETY-NINE STARES
ENDURE NINETY-NINE CARES
SAY NINETY-NINE SWEARS
AND BE FINE NINETY-NINE PERCENT OF
THE TIME
I AM NINETY-NINE PERCENT SURE THIS
LOVE WE SHARE IS
99.99999999999999999999999999999
99999999999999999999999% PURE

[Punctuating the ninety-nine poem are the
hands of Brooklyn legends Mel Brooks, Jackie
Robinson, Eric B., Big Daddy Kane, and Biz
Markie.]

I GREW UP IN YOUR ARMS,
RAISED TO TAKE FLIGHTS
OWNING THE GROUND I HELD
STEEPED IN YOUR STORIES

I AM UP WAITING FOR YOU

[Painted above is a tower block with one
window lit.]

DOLLAR HERE
DOLLAR THERE

[Two dollar vans are painted here going back
and forth, in tribute to the dollar vans that drive
up and down Livingston all day and night.]

HUNDRED HUSTLERS HUSTLE FOR
HUNDREDS
SLEEPLESS ENTREPRENEUR TURNS A
BUCK INTO FOUR
BARKERS CALL ME TO SHOP AT STORES
SOME ARE SELLING ROCKETS
SOME ARE CHECKING POCKETS
SOME ARE ON THE DOCKET
I WALK UP THE BLOCK, MONEY IN SOCK
PAST PITFALLS THAT FACE ME
TO BUY CLOTHES AT MACY'S
Dave At The End Of Sixth Grade c. 1980

And, finally, on the skyways:

TURN TO ME
I SEE ETERNITY

EUPHORIA
IS YOU FOR ME

A LOVE LETTER TO THE CITY

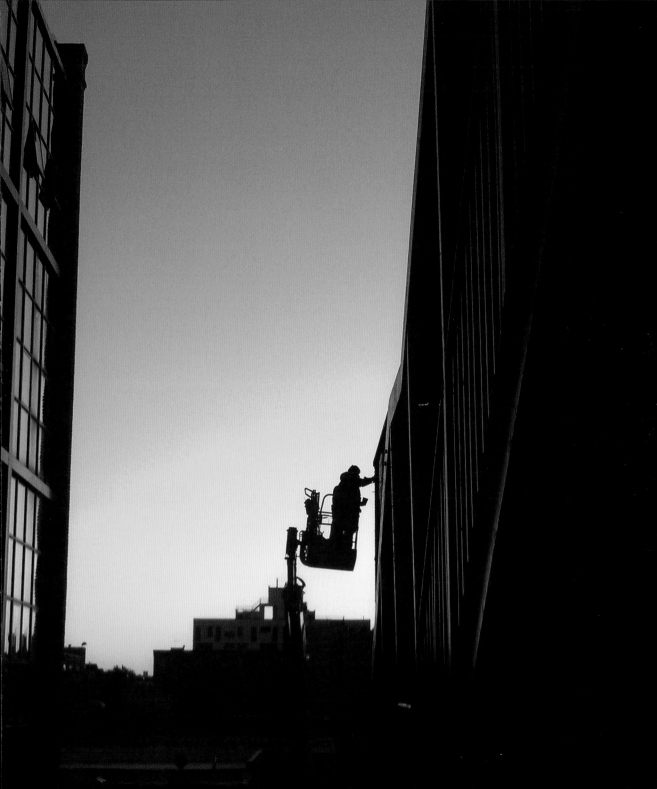

HUSTLERS HUSTLE

ENTREPENEUR TURNS A DOLLAR INTO FOUR BARREL

SOME ARE CHECKING POCKETS SO

ING ROCKETS

NEY IN SOCK PAST PITFALLS THAT FACE ME TO BU

-Dave A

ME ARE ON THE DOCKET

Y CLOTHES AT MACYS

The End Of Sixth Grade c.1980

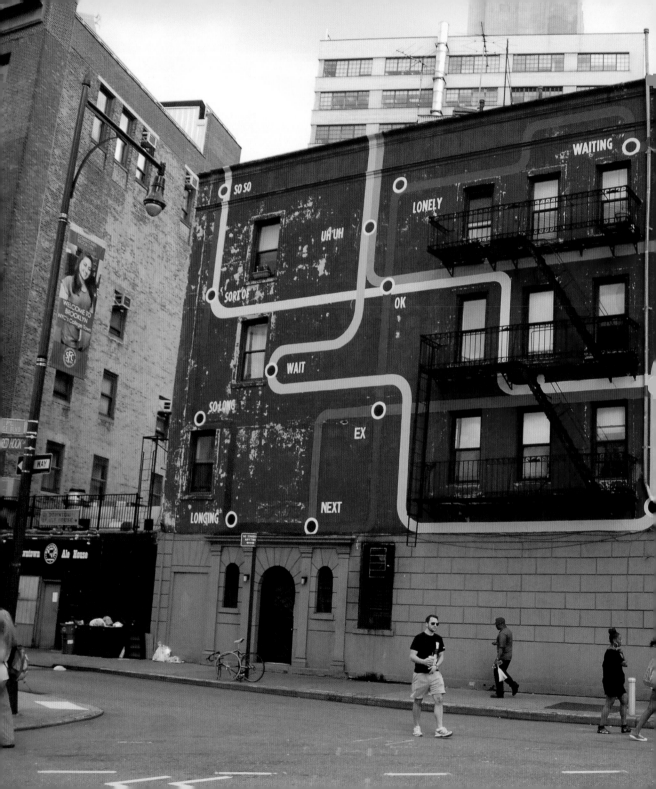

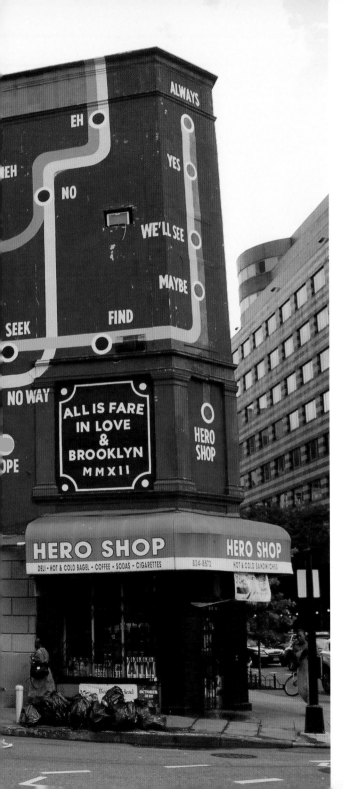

**left:** *Train to Always*, painted by Mike, Pat, Lew, and Dan on a balmy sixty-degree New Year's Eve and New Year's Day, 2010. The Hero Shop has a Steve Powers hero, which I've never had. It's got three kinds of pork on it. The owner also decorated the ceiling of the shop to look like a subway map. I think the stops are named for sandwiches. I couldn't really focus—my mind was blown.

**next spread:** Dollar here, dollar there

AR HERE

R THERE ➡

# JOHANNESBURG

Photos by Martha Cooper

Johannesburg, South Africa, is a sprawling metropolis that is still suffering from a post-apartheid hangover. Thousands of buildings are empty or half-empty or have been hijacked by gangs who collect rent from refugees from the townships that surround the city. The people who call Johannesburg home possess a savvy resilience you would recognize in a Lower East Side, New York City, resident of the early 1980s or a Bom Retiro, São Paolo, resident of the late 2000s.

**left:** Real estate, as far as the eye can see. Looking at this, I can smell the wire fires that were constantly burning in the neighborhood, set by scrappers harvesting the copper at the core.

**next page:** We went from Market Street in Philadelphia to Market Street in Johannesburg. You can't spell "progress" without "ESPO."

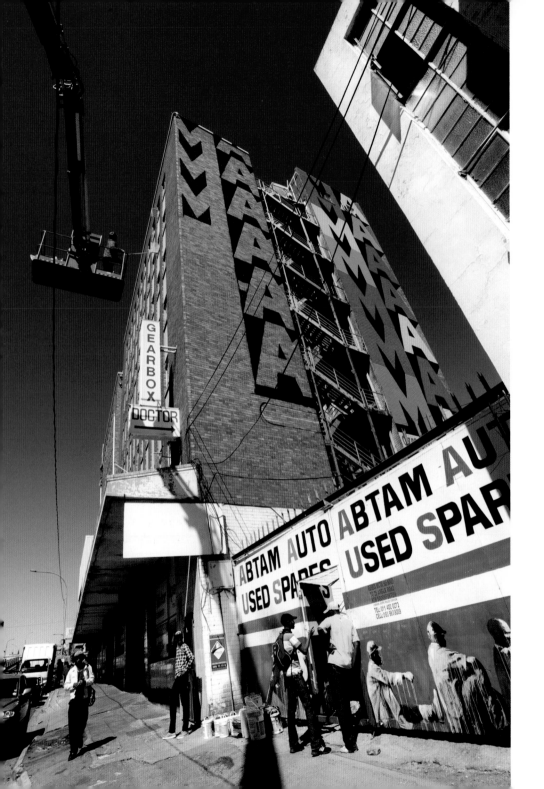

There are equal parts trouble and triumph everywhere you look. For triumph I didn't have to look any farther than the hand-painted signs that are everywhere in the city. It's as if the vinyl plotter never arrived to these shores. Sign painting still flourishes as a craft, and we were thrilled to see and meet sign mechanics pursuing their vocation in the neighborhood where we were working.

We arrived for a ten-day stay to find that we were tasked with painting walls to advertise the gentrification of a neighborhood called the Gauteng Precinct, which had been renamed Maboneng (translated from one of the many local dialects as "city lights"). We spent a day in the company of a local resident named Bheki, who was casual and formal at the same time. His gregarious smile and jovial banter were joined with a precise and direct way of speaking. Bheki led us through dense streets to a tower where we could get a 360-degree view of the city (once he had blagged our party past guards who insisted the tower was closed). At the top of the tower, all of Johannesburg surrounding us, he pulled a pin out of his pocket that identified him as an official tour guide and put it on his shirt. He shifted slightly from insider to official as we shifted from truants to students, and he told us about the topography and history of Johannesburg. It's a long story of evil and money, and as he talked, I could see that Bheki and his generation of millennials are the end product of that history, and the future of Johannesburg is in their hands.

"So, Bheki, what should we paint?" "*Stay up, stay rising!*" he replied. He said it repeatedly, until the mantra took hold and we took it to the wall. The site was an amazing interchange where the major thoroughfares of Market Street and Commissioner Street cross each other underneath an elevated highway, making it, as far as spots go, ideal. We had a lift and a security guard, but we needed a power sprayer to handle the wall's rough brick surface. Sourcing required negotiations with a car painter from Soweto and further negotiations with his wife, who was certain we were pulling a scam. The sprayer, designed for thin oil paints and not thick latex, took some coaxing to work, but work it did—unlike the lift. On our first day of painting, we realized that somebody had loosened the contacts on the lift's battery. Clearly, he had been trying to steal the battery but needed a wrench to finish the job. He returned the second night and got the battery, in spite of a guard hired to watch the lift all night. Despite these setbacks, we finished the preliminary spraying in three days and still had a week to paint *Stay Up*.

Nearby, looming over the precinct, was a ten-story wall that Remed, a Spaniard brimming with talent and romance, had started to paint, but he had run out of time before he could realize the potential the wall presented. We looked at the wall for a few days and decided we'd ask him to let us finish what he'd started. Remed agreed graciously, and we set out to solve all the problems involved in painting the architectural monstrosity. We had three days left, with the first day given over to negotiating access and getting supplies. We needed a fixer, and a local named Ronin appeared before us, listening and laughing at my accent: "You talk very low and fast. You must be from America. Not New York—maybe DC or Philadelphia." We laughed and marveled at his accuracy. He wanted to

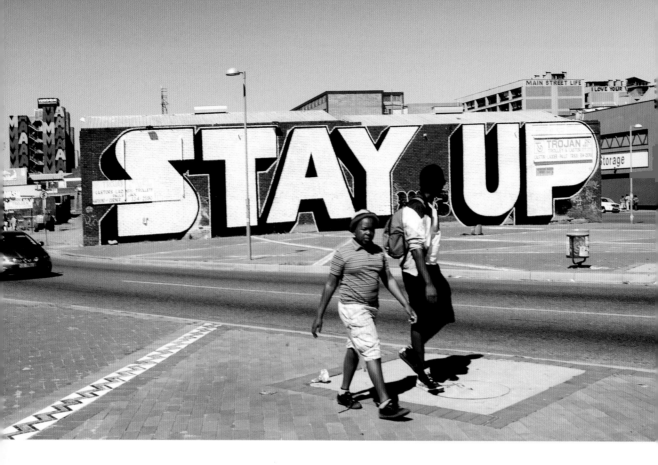

**above:** *Stay Up is* painted on the Trojan Castor Supply Company. Castors are crucial to the local economy, as every scrapper transporting recyclables uses a cart with castors. Time and time again, I would see a scrapper bombing the hill on Market Street on a cart loaded down with a four-foot pile of material, going about fifteen miles per hour, looking like he was doing sixty. Usually the scrapper was wearing a ski mask. A local writer, Rasty, told me that it was because scrappers tell their families they have good jobs in the city and hide their faces to maintain the fiction. He also told me that if he busts his ass, a scrapper can make fifty dollars a week.

**opposite:** Who am I wearing? GANJA FARMER hat, Guided By Voices shirt, black 501s, and black Adidas Forums painted white. The swankers of JoBurg said I had good style—ask Kenny Meez.

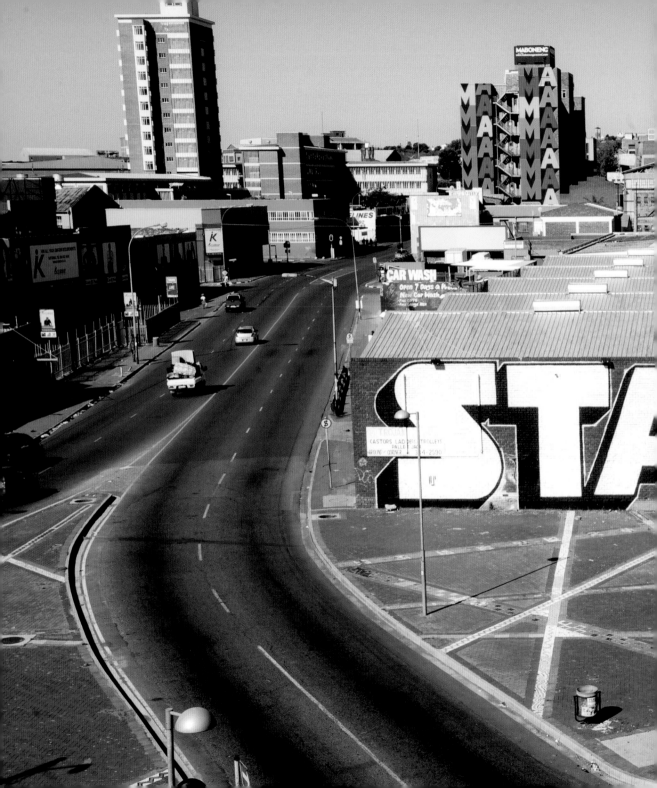

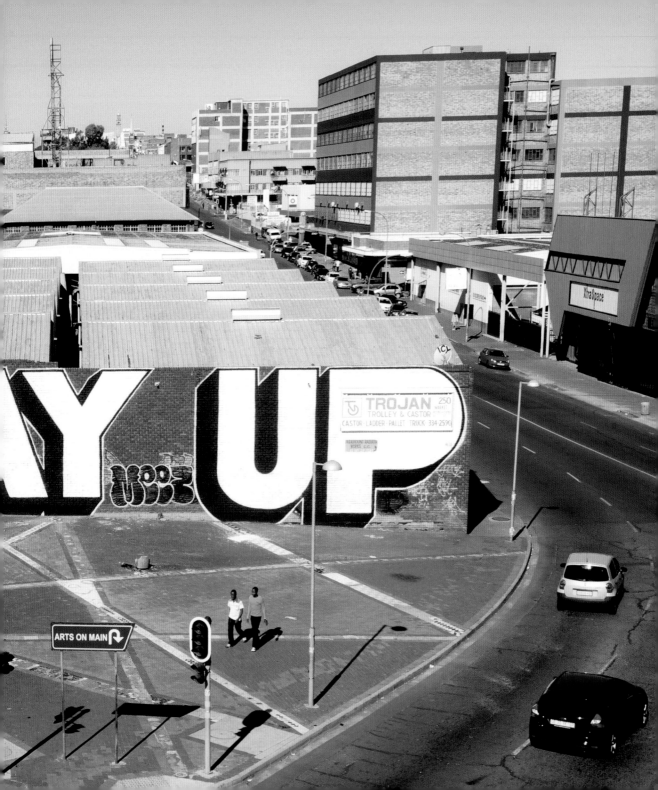

**Ricky Lee Gordon (Freddy Sam)**
*Founder, A Word of Art*

I wanted to curate a mural art project in downtown Johannesburg, inviting artists whose work would fit into the landscape. With all the hand-painted signage on the streets of Jozi, I knew not only that Steve's work would suit the landscape well, but that he would be inspired by South Africa.

I realized very quickly that Steve was here to work, as he requested a second, even bigger wall, promising to "do a good job and create a mural that would last twenty years, satisfaction guaranteed."

I believe that removing the grayness from the soul of the city is the job of artists, musicians, and poets, and Steve represents this in its purest form. He cares about what the community wants to see.

I remember something he said that will stay with me forever: "Art's got to serve the community if it's going to be in the community. If it's in the community, that's where it manifests real power."

help us help him: "This place needs all you can give it. You can move into the building, take ten floors rent-free." The building we were painting was empty except for a makeshift recording studio on the top floor with an amazing view of the city. Electricity is easy to get in Johannesburg, and people tap into lines everywhere, but getting running water is impossible—hence the awful smell emanating from the city's hijacked buildings packed with humanity. I processed the possibility of a ten-story residence (in contrast to my six-hundred-square-foot apartment back home) and settled for painting the exterior surface.

At this point I should introduce the two people who would help me to paint a ten-story building in (now) two and a half days: Lew Blum and Kenny Meez. Lew Blum has assisted me in making art and painting signs for twelve years, and he does his best work in places where he can surf. Johannesburg offered no such possibility, but it being Africa, Blum still rose to the challenge in style. Our usual third man, Dan Murphy, was home with a newborn girl, so Blum suggested we bring Kenny Meez along for style consultation. I've known Meez since he sussed out that I was ESPO on a bus in West Philadelphia in 1989. In the intervening years he's always known the exact color I should use on a wall and the exact course of action I should take to get something done. So he was a perfect collaborator, impeccably dressed, sitting on a chair in the shade, yelling up that we should use more green. It was Meez who spotted the first of many "Mama Africa" signs we saw throughout Johannesburg. He referenced the Garnett Silk song, and I was thinking the Peter Tosh anthem, but it was a vibe we both lit on right away as we walked the streets.

To paint "MAMA" in a recurring pattern required figuring out a simple way to work out the size of the letters and execute all the repeated angles while 120 feet up in the air. The available harnesses inspired no confidence, so we went without. While I had some experience on a 120-foot lift, Blum had none, so we had a tense time controlling our nerves while we solved the visual problems the wall presented. I had faith in the machinery, and the lift came with a proficient operator who knew all of its ins and outs and patiently explained every inch of the equipment to us. Blum listened and learned—he had little faith in the machinery and less in me, so he would be the sole driver of the lift. By the end of the first day—with the only paint we had, a can of white spray paint—we had scratched out an *M* and an *A* and had a sense of how the letters would look. We also wrote some names of Philadelphia graffiti writers, as we felt we stood on their shoulders—the first time these names had appeared in Africa. The next day the owner of the building called in more security because he thought some local vandals had commandeered the lift to vandalize the building.

The next question was which colors we were going to use. Remed figured it out first, and Blum and I soon realized that the best colors of the country were right above us. We would use the color palette of the South African flag: primary red, blue, and yellow, signal green, and black—perfect. This would eliminate the need to explain exactly what red and what blue we needed. The paint arrived on time, and we started applying it with the most primal tools: rollers and extension poles. The oldest ways are sometimes the best ways. One amazing factor in our favor was the African sun. It cooked the

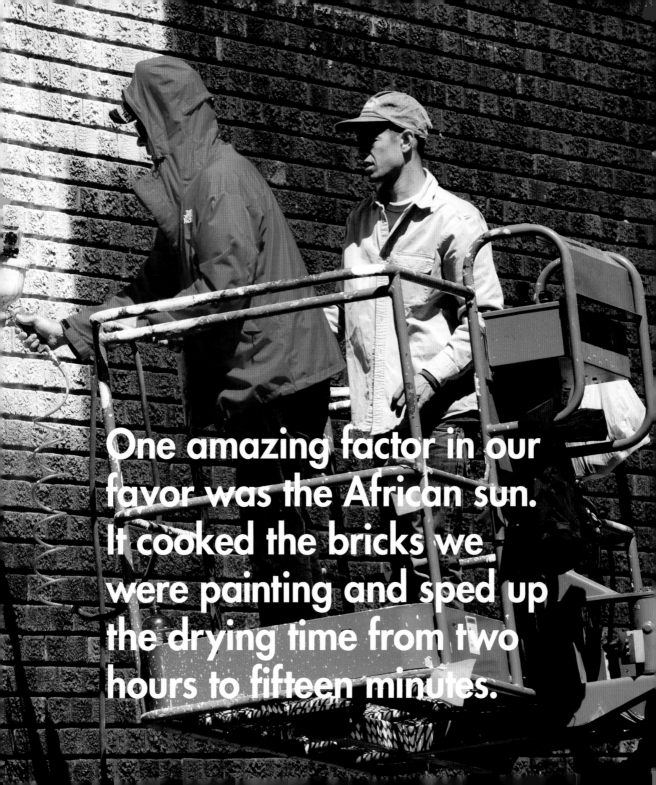

One amazing factor in our favor was the African sun. It cooked the bricks we were painting and sped up the drying time from two hours to fifteen minutes.

 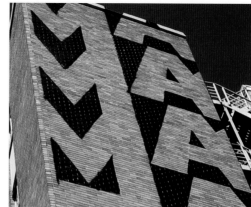

**above:** The prophetic transistor and the poetic manifester

**opposite:** Every word and number in this picture, except for the little yellow sign and the bags the passersby are carrying, is hand painted. Big up to 2Kiler, who was up on the wall first.

bricks we were painting and sped up the drying time from two hours to fifteen minutes.

We were still stressed out from being up on the lift, and the higher we got, the more our nerves were fraying. But a couple of sights made us believe in the destiny of it all. The first was a simple stamp on a brick near the top of the wall: a pyramid made of three 3s. Blum exhaled and felt the pyramid's power: "OK, I'm feeling a lot better about this." A couple of hours later, I found a radio transistor wedged in between two bricks nine stories up. It had an arrow-like graphic on the side that matched the arrow-like shape formed by the negative spaces in the stacked *M*'s we were painting. It went beyond coincidence to predestination, and we suddenly gained the momentum to finish. In spite of being shut down by winds for five hours and waiting for gas for a couple more, we finished painting the wall with plenty of time to eat Ethiopian food at—of course—Mama's Kitchen.

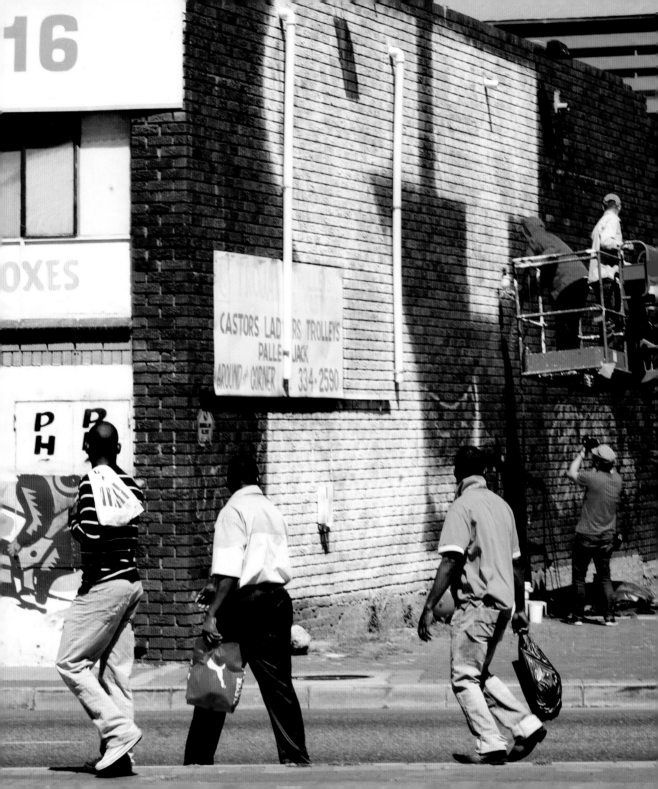

# ICY SIGNS

The last few years I was painting graffiti, I was
painting my name like an advertisement. ESPO
was the logo. There was always snappy copy,
and if I could fit it, I would add a character pointing
to the name. With all three elements, you have the
ultimate trio that is outdoor advertising past, present,
and future.

Don't call Kevin Tolan. After the first five hundred calls
he and Katie Lyon took, they turned off the line. Window
splash by Sean Barton.

# Perfection is Standard Mistakes Cost Extra.

Perfection script and ICY Signs logo by Sean Barton of Barton Signs

When I went into the art world, I took sign painting with me, at first just making signs that advertised to the gallery and museum audience what I had on offer: Confidence, Belief, Flavor, Street Cred, Meaning, Identity, and Work. The signs I painted looked proficient, but were done in a very fussy way that legitimate sign painters would consider too slow for making a living. It was fine art, so it was all good, but I was really interested in painting fast and accurately, so I started learning the trade all over, under the guiding ethos of master sign painter Justin Green.

Justin was a cartoonist who started sign painting in 1975 to support his young family. He aspired to be a bench man—someone who could handle any job that came in the sign shop. To maximize his profit margin, Justin specialized in a style he called "Bashed Out," painting very fast and pushing the boundaries of what a client would deem acceptable. Any job that could be bashed out was a profitable one.

When vinyl lettering took over, the salesmen sold the "perfection" of vinyl for the same price as hand-painted work that invariably contained flaws, so Justin found himself scrambling again.

In 2002 Bashed Out was exactly what I had been looking for, and it's what ICY Signs is all about. Our motto is "Perfection is standard, mistakes cost extra." We strive for work that is fast and without artifice. We paint as we speak: plain, direct, and to the point. We applied the Sonic Boom adage about music to art and signs: one color best, two colors great, three colors good, four colors average.

ICY Signs was established in 2003, with the advent of the Dreamland Artist Club sign shop in Coney Island. This was the first iteration of a traveling sign shop that moved to galleries and jobsites in Milan, Brussels, Copenhagen, St. Louis, Los Angeles, Philadelphia, and Brooklyn. There are now two permanent ICY Signs shops: in Brooklyn at 72 Fourth Avenue and in Philadelphia at 2819 Girard Avenue.

While ICY Signs changes the look of our cities for the better, I am making bashed-out paintings that distill life into visual blues. I paint in a couple of formats. The first I call "Daily Metaltations," small 8" x 10" paintings that I produce daily, fast and fresh from the epiphanies that inspire them. When I get burnt out from painting too many of those in a row, I switch to larger 48" x 48" paintings brimming with words and images that form icons of the human experience. If you find your eye ricocheting around the composition and making connections or marking distances among the various icons, thank you.

I'm also striving to be a twenty-first century cave painter, depicting our life and times on the walls around us. If the power goes out and the books are gone, the walls will be there, testifying.

Justin Green hiding a few sins on our collaborative
"Fast nickel better than slow dime" gold-leaf
sign, donated to the Coney Island Museum

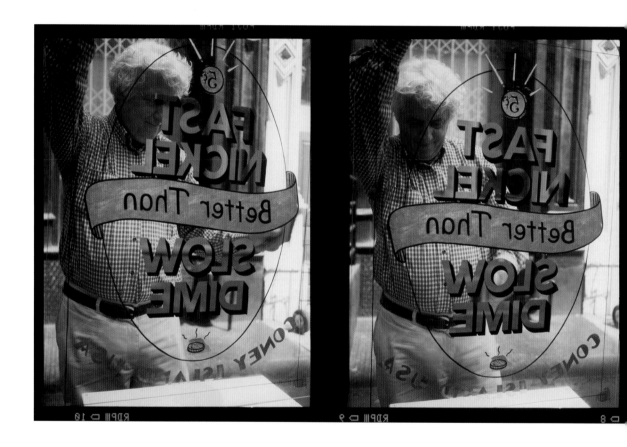

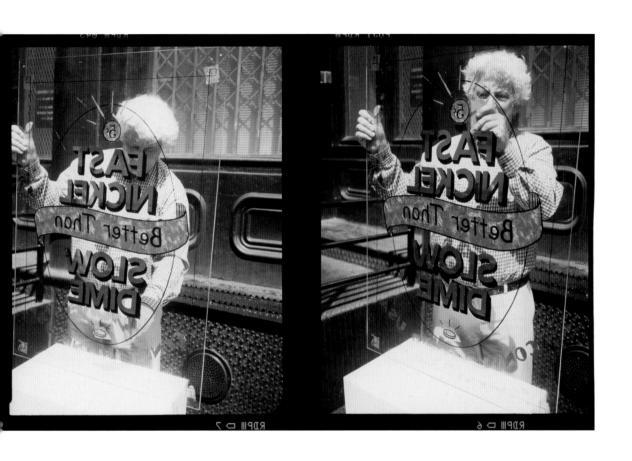

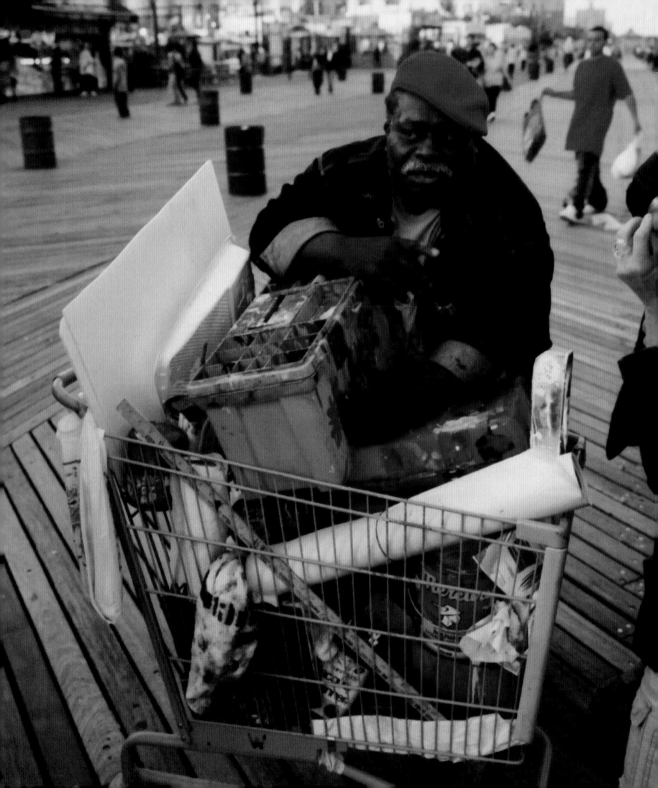

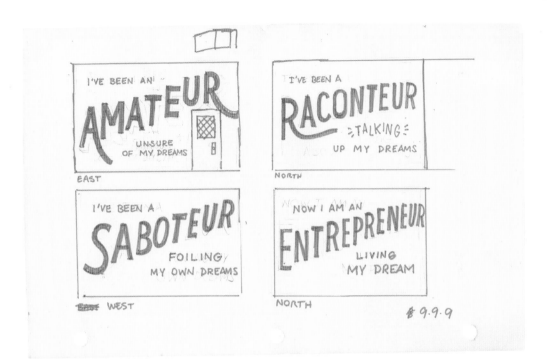

above and right: Sketch comedy

opposite: Coney Island legend and sign painter Henry Wallace. (I should have bought this cart off of him then and there.)

**above:** The ~~lost~~ found art of bodega signage. PURE TFP on the spray.

**opposite:** On the ~~job~~ go

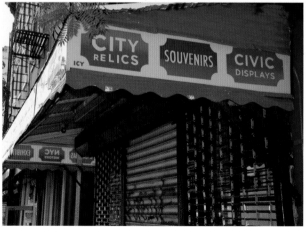

A LOVE LETTER TO THE CITY

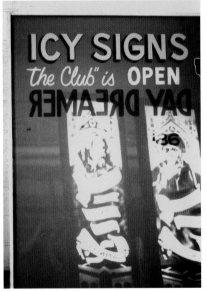

FULTON EYES
OPTICAL

472
B

472
B

BUSINESS HOURS
9:30 - 6:00 M-Sa
12:00 - 5:00 Su

PUSH

DR. SARANTAKOS
OPTOMETRIST

FLEX
SPENDING

WELCOME
HERE

ICY SIGNS
The Club" is OPEN
DAY DREAMER

36

ICY SIGNS

The sign table at 72 Fourth Avenue

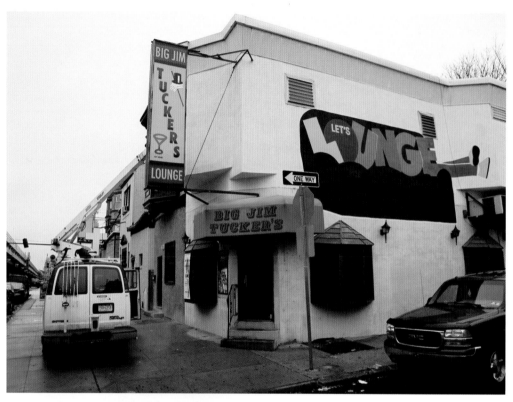

**above:** Big Jim Tuckers Lounge at Market and Ruby Streets, Philadelphia

**left:** Philly branch of the ICY Signs shop on Girard Avenue

**opposite:** Improving the neighborhood, one sign at a time

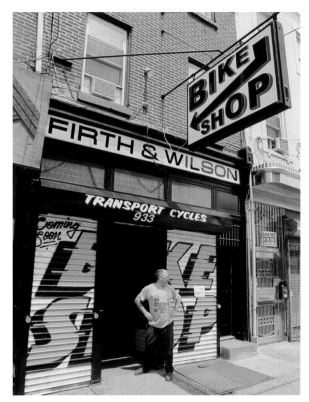

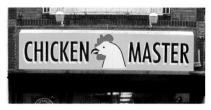

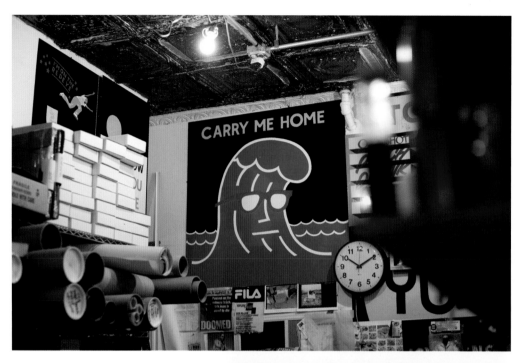

Art and commerce collide in the back room.

A LOVE LETTER TO THE CITY

# LOVE SUPREME

**Coney Island:** Dick Zigun, David Gratt, Aaron Beebe, Joey Clams, Alexa Coyne, Peter Eleey, Matt Wright, Mike Lee, Ned Vena, Anne Pasternak, Alexis Ross Finn, Sean Barton, and Cookie Ciminieri. Meet me at Totonno's Pizza.

**Dublin:** Ed Carroll, Niall O'Baoill, Prof. Brian Maguire, Niall Moore, Declan McGonagle, Declan Lennon, Olan at All City Records, Konk, Magnus Mudrack, OMIN, ROLK, and KUBE. Meet me at Mulligan's of Poolbeg Street. In Belfast, everyone in the Lower Shankill, Loko Skate Shop, and Graham and Glen. Meet me at the Duke of York.

**Philly:** Paula Marincola and the Pew Philadelphia Exhibitions Initiative, Jane Golden, Amy Johnston, Nancy Davis and the Mural Arts Program, Thora Jacobson, Catherine Ott Lovell, Mayor Michael and Lisa Nutter, Joey Garfield, Brian Campbell, Adam Wallacavage, Zoe Strauss, James B. Jones Jr., Joey Gallagher, Matt Gallagher, Kevin Brown, Seth Turner, Ryan Spillman, Craig Turner, Carlos Vasquez, HOTHEAD, Kurt Heasley, and especially Maryanne and Malcolm Powers for being the MAPS and the muses.

**Syracuse:** Maarten Jacobs, Shoham Arad, and Chris McCray. Meet me for the hot oil sauce at Bread.

**São Paulo:** Danilo Oliveira, SESC, Flavio Samelo and Jayelle Hudson, Os Gemeos, ISE, Finok, Toes, and Lixomania. Let's get some Acai!

**Brooklyn:** CHINO, BYI, Joe Chan, Katie Lyon,  Kevin Tolan, Andrew Peerless and Jamestown Properties, Two Trees Management and Jed Walentas, Marty Markowitz, Blake Lethem, Syd, the Wythe Hotel and Andrew Tarlow, Gus Powell, Annica Lydenberg, and Andrew Raskin. Meet me at Stur-Dee Health for juices.

**Johannesburg:** Ricky Lee Gordon, Martha Cooper, Phil Botha, The Farmers, Kenny Meez, Ronin, Bekhi, Rodriguez, and JoBurg. Let's get Ethiopian food!

A special thank you to Merrell Hambleton for the focus and Matthew Kuborn for the perspective.

The ICY Sign mechanics include everyone who has worked on the Love Letter projects: Lew Blum, Dan Murphy, Matt Wright, Justin Green, Sean Barton, Mike Lee, Pat Griffin, Alexis Ross, SEVER, SKREW MSK, EWOK HM AWR MSK, POSE MSK, Darin Rowland, ESTEME TGE, Andy PURE TFP Dolan, Sam Meyerson, Tim Walkiewicz, MESE BDR, BRAZE BOLD ART, STAK TFP, Greg Lamarche, LE JOSH, Matt Harkin, James B. Jones, Nassir, Annica Lydenberg, NEKST MSK (RIP), and many others with a good hand and a good word.